A PALPABLE ELYSIUM

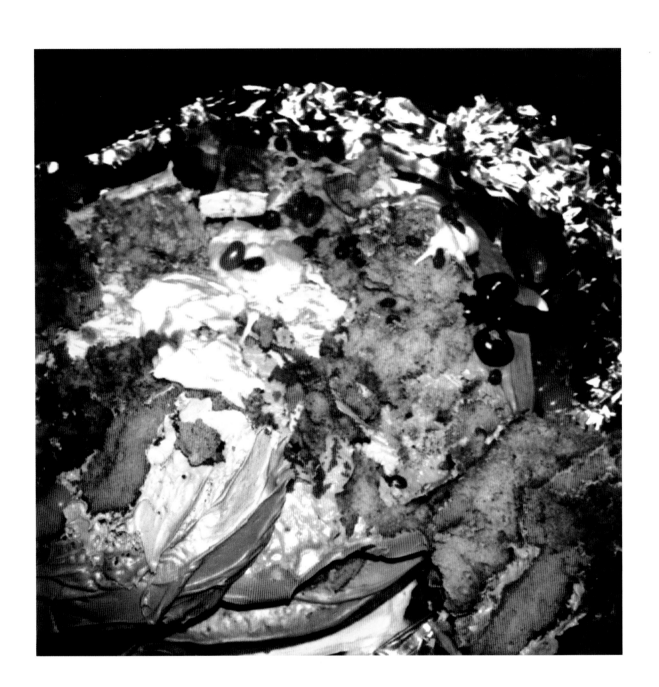

A PALPABLE ELYSIUM

PORTRAITS OF GENIUS AND SOLITUDE

Jonathan Williams

Introduction by Guy Davenport

David R. Godine · Publisher

BOSTON

First Published in 2002 by

DAVID R. GODINE, *Publisher*
Post Office Box 450
Jaffrey, New Hampshire 03452
www.godine.com

LIBRARY OF CONGRESS CATALOGING-IN-PUBLICATION DATA

Williams, Jonathan, 1929–
A palpable elysium / Jonathan Williams.
p. cm.
ISBN: 1-56792-149-3 (softcover : alk. paper)
1. Arts, Modern—20th century—United States. 2. Black Mountain College
(Black Mountain, N.C.)—Faculty—Biography. 3. Black Mountain College
(Black Mountain, N.C.)—Alumni and alumnae—Biography. I. Title.
NX504.W55 2000
900´.92´275688—dc21
[B] 00-059339

FIRST EDITION
Printed in Hong Kong

The image on the frontispiece is a cross section of true esculent orogeny: a piece of a "Grand Canyon Cake" from *White Trash Cooking*, by Ernest Matthew Mickler. It was created by Thomas Meyer and Jonathan Williams took the Polaroid. Ernie said: "This is a wonderful treat for someone that's going to, or just got back from vacationing at, the Grand Canyon. It's also very educational for children." We remember the late Ernie fondly. At the first big dinner party in honor of the publication (which was at Ranleigh Manor, McLean, Virginia in the spring of 1986), when Ernie grabbed two big forks, stuck them in the top of the cake, forced open the cracks so you could see the colored layers, and poured whiskey sauce into the cracks that made the jelly beans look like boulders in an earthquake, it was enough to make Jim Lehrer, of PBS's *News Hour*, hoot and holler. It's the only time I have ever seen him crack up.

CONTENTS

INTRODUCTION

THIRTY-EIGHT YEARS AGO, when the epochal sixties were just beginning their long catastrophe, Bill Chace, a student of mine at Haverford College (now President of Emory), lent me a book of poems by one Jonathan Williams, *The Empire Finals at Verona*. Its cover (by Fielding Dawson) was brash and new, its beautiful typography was new, its spirit was new, and its voice was new. Moreover, Ralph Sargent, a botanist and professor of English at Haverford, was bringing the poet himself to give a reading on campus. I wish I could delete from my memory that I went to this meeting with a French professor who suspected all poets of being pederasts, Jews, Communists, and the kind of riffraff Hitler (his hero) would know what to do with (Haverford faculty were *very* strange.) Jacques whispered to me as the reading began that Jonathan was wearing a toupee. And do you call this *poetry?*

Me, I was delighted. I met Jonathan at Ralph Sargent's house the next day but didn't get to know him well until he came for a visit in Kentucky the following year. Thereafter, there have been many visits, hundreds of letters, books (he published my *Flowers and Leaves*), collaborations, epic conversations, and shared events such as meeting Ralph Eugene Meatyard and Thomas Merton. He found me my copy of Doughty's *Dawn in Britain* in an English bookshop. What I've learned from him about people and books, poetry and art is so immense that I place him among my best teachers.

Well, a kind of teacher: the best kind. A good teacher knows things in a way that makes you want to know them too. After Sputnik went up, and our emulation of it fizzled and dropped off the launching pad, Washington made a quick survey among scientists to see how our money was to be thrown, where and to whom. To Buckminster Fuller's delight, Washington discovered that scientists come from anywhere. Who were their teachers? Dedicated, undistinguished teachers whom their students *liked*. Bucky Fuller himself, the Leonardo of our time, evolved his geodesic and tensegrity structures at Black Mountain College in the wilds of North Carolina, an eccentric place with the poet Charles Olson as its rector. Black Mountain was a reinvention of the university: a *collegium* of scholars and students, very 12th century. Oxford, Bologna, and the Sorbonne began this way. You sat down with Robert Grosseteste and Thomas Aquinas and they showed you what Aristotle wrote and what they had to add to it. "Standing on the shoulders of giants" they called it over at Chartres.

The giants at Black Mountain were Josef Albers (painting) and his wife Anni (textile design), Eric Bentley (drama), Merce Cunningham (choreography), Walter Gropius (architecture), and about forty others — Motherwell, Rauschenberg, Arthur Penn, Robert Creeley, Alfred Kazin, Edward Dahlberg, John Cage. An interesting statistic would be a Black Mountain student or teacher who *wasn't* famous. And here the St. Albans schoolboy, Jonathan Williams, became a poet, photographer, book designer, publisher, and missionary explorer of all the arts.

Black Mountain lasted scarcely twenty-three years. It began as a school where idealistic teachers wanted to work with real students: not sorority sweethearts and fraternity oafs, Education majors and pre-Law hotshots, but *students*.

From the *collegium* so intensely focused at Black Mountain, a gathering that was by nature volatile and transient, Jonathan set about an inventory of poets, painters, architects, and other lively folk distributed around the republic and the world, meeting them, photographing them, showing them on color slides to small groups who turn up for such things. These magic-lantern shows have a charm all their own. They are congenially an intimate and privileged occasion. Jonathan always gives the knowledgeable a chance to say "That's William Carlos Williams." More usually, there's silence. But once Jonathan has identified Louis Zukofsky, Stevie Smith, Lorine Niedecker, the sense is established that *all* these people are distinguished. They are celebrities who aren't ever going to appear in *People* or in conversation with Oprah.

I saw Paul Metcalf on a Jonathan Williams slide before I read him. And learned about Lord knows how many others, especially folk artists like Simon Rodia and *le post facteur* Cheval, never mind all the black geniuses of Outsider Art who figure so wonderfully in this book. To have found them is an heroic task, to have won their confidence, another.

As far as I know, Jonathan's exploration of the arts is unique. He is not a journalist looking for feature stories, or a critic with an agenda, or a lion hunter collecting names to drop. A cultural anthropologist? I see parallels with Ruskin finding forgotten Trecento and Quattrocento painters, illuminated missals, and the Pre-Raphaelites. Or Crabbe Robinson looking in on William Blake.

We know the arts as the media feeds them to us, poetry as it is chosen for us by anthologists and English profs, prose as publishers let us see it with an eye for profit. What publisher will print Henry Darger's *Story of the Vivian Girls in the Realm of the Unreal and the Glendeco-Angelinian War Storm* (15,145 pages of typescript, with illustrations, in which the Morton Salt girl, Little Orphan Annie, and an army of agemates generaled by Booth Tarkington's Penrod take on the Forces of Evil)? Walser's *Geschwister Tanner*? Doughty's *Dawn in Britain* (out of print for 57 years)? Who remembers Kenneth Patchen?

To Jonathan we owe our knowledge of Paul Metcalf, Lorine Niedecker, "St. EOM," Tom Meyer, Ian Hamilton Finlay, Zukofsky (in part), Basil Bunting (again, in part). And those are just the people in this selection of his photographs. A full list of the discovered would be impressive, and a

surprise to those who think they know a thing or two. Every age has its own past. And its own ignorance. Melville was recognized as a great writer in the 1940s; Vivaldi as a great composer in the 1930s. Hopkins and Emily Dickinson had to wait years. In a sense, we still haven't read Whitman.

Jonathan Williams's photographs are an index. His comments range from the whimsical to the sharply perceptive. He has no theory, no stance, no nostrums. He knows what he likes and what he hates. It is his opinion (in conversation) that lots of people who think they are alive are actually dead.

Photographers are persnickety bullies, nattering about angles and light and smiles and saying cheese. They shoot a roll of film. Not Jonathan — he takes one exposure, with little warning and no bullying. In these portraits Stevie Smith has just turned around to a "would you mind?" James Laughlin is unaware that he's being photographed at all. Lorine Niedecker is being polite and Zukofsky brave. Tom Merton, obliging. Ezra Pound is furious and Charles Henri Ford desperate. Each photograph is simply a moment in a conversation, though wit has gone into choosing backgrounds.

The least-known publishing house in the USA is Jonathan's Jargon Society. All of its books are splendidly crafted, meticulously edited (in an age when even *The New Yorker* offers as literacy Ford *Maddox* Ford, O'Henry, Paul Zukovsky, and *egg yoke*), and so avant-garde that only once in awhile do other publishers catch up with it. My first go at writing about Jonathan had for its title, *Jonathan Williams, Poet*. His poetry is the nucleus of his being, the radiant center. He has never written or spoken a dull sentence.

He calls this choice selection of his photographs a palpable Elysium. Main Street in Paris, France (as tourists say) is The Elysian Fields, one end of which is Napoleon's Triumphal Arch. At the other end is the Louvre — Force and Spirit. In the celestial edition of this book, Jonathan's Elysian Fields will depict William Blake and Catherine, Samuel Palmer, Gustav Mahler, William Bartram, John Clare, Christopher Smart, Gaius Valerius Catullus, Anton Bruckner, and Walt Whitman.

Let the magic lantern do its stuff, and let's listen to the man who took the pictures.

Guy Davenport
January 26, 2000

FOREWORD

HENRI CARTIER-BRESSON suggests that "photography is pressing a trigger, bring-ing your finger down at the right moment." If that's all there is to it, I am just about *in with a chance*, as our English cousins say. It would still be pretentious for me to set up as Photographer in the same way I set up as Poet, Essayist, Publisher, Hiker, Bourgeoisophobe, and Dotty Anecdo-tist. One hopes that "professionals" will simply allow me to be a literary gent who takes the odd tolerable picture. The man who makes the tolerable pictures possible is my old friend, David Kooi. Dave worked as a lab technician at the *Hartford Courant* newspaper and was able to trans-form my tattered color transparencies (some nearly 50 years old) into creditable digitized prints. Other people have tried, but Dave Kooi's are definitely the best.

With Rollei, Mamiyaflex, Hasselblad, and SX-70, I have pressed triggers in a very simple, straight-forward, square way. (My poems are even more laconic: Les Moore is more or less Les Moore.) I notice there is a lot of "quiet" in the pictures. Many were shot shortly after food and drink had been taken. You see people both relaxed and ruminating. These people were friends, not celebrities on the prowl, pressing the flesh. Many pictures were snapped in cemeteries and gardens and while poking around buildings. STOP LOOK (OCCASIONALLY) LISTEN seems to be have been the order of the day. The fact that I can, now & then, actually manage to load 120 film into the Hasselblad means we are in post-virtuoso hands. Shoot from the hip, shoot with your eyes closed — things will (sometimes) happen — even art. In Bali they have no precise word for art, because cultural tradition expects everything to be done as well as humanly possible. Bali sounds like the place to live, even better than Orlando or Atlanta.

I woke up one morning with the title, *A Palpable Elysium*, in my head and, at first, thought it was all mine. Little, of course, is ever all ours. Thus, I eventually re-encountered the two words in "Canto LXXXI," by Ezra Pound, the one with the two glorious lines:

"What thou lovest well remains,

the rest is dross . . ."

It also is where he implores himself and all others to "pull down thy vanity." So, I can only pray, with mentors as splendid as Cartier-Bresson and Ol' Ez, that I have put images and words on paper that won't waste your time. In the mountains where I live (North Carolina and Cumbria),

people are naturally taciturn and worry about "a-hesitatin'" others. They are very "composed" people, not about to be rattled by what is going on in Soho and Chelsea and on 57th Street this season. EP again: "Learn of the green world what can be thy place..."

In the 1960s I started doing a lot of hiking and wandering. Much of the Appalachian Trail, the English Lake District, the Wye Valley on the Welsh Borders. I still walk a bit in the Yorkshire Dales. My last big walks were across the Basque Pirineos and around Mont Blanc in the Alps. Except for two sojourns in London (1962-63 and '65-66), I haven't lived in a city in 35 years. I enjoy the speech of countrymen. I enjoy country music, but unless it's being played by people as good as Earl Scruggs or Vassar Clements, I stick with Anton Bruckner and Frederick Delius for aural mountains and summer gardens. Increasingly, I become less and less interested in urban concerns and America's relentless, barbarous entertainment culture.

This should come as no surprise. I'm the guy who dropped out of Princeton after three semesters, because everybody looked like George Bush or James Baker. James Baker actually *was* James Baker, Class of 1952. Big money was on their minds in a big way. But there were other reasons. A friend wrote recently: "If I seem hipped against Yale, it's because I had a lover from there, a boy who, when we met, was an enthusiastic, passionate art-lover, full of zest and fun, his intelligence (you have to be smart to get into Yale) a-whirr and observant. I watched him as he went through Old Eli growing steadily more uptight, paranoid, conventional, contemptuous, and cynical. He emerged from the ivied halls an unprincipled careerist closet-queen. His friends followed suit." What a future — sixty more years of mandarin country clubs and all that golf and huntin' and fishin'.

My attention settled more and more on homemade things made by people on the Outside, beyond the pale. Black, white, Native American; often uneducated and very poor. Isolated people who made poems, hill farmers who made beautiful dry stone walls, artisans who made proper Lancashire cheese or onion relish or ginger chutney. My small press, The Jargon Society, published the poems of an extraordinary recluse named Alfred Starr Hamilton, hidden away in the Republican town of Montclair, New Jersey. We felt no need, and no desire, to publish the poems of Robert Lowell. This is why the money in the New York Art World gives me the creeps and why I feel no need to keep up with my contemporaries at Black Mountain, Rauschenberg and Twombly — they are not short for attention. I'd rather be in Pinnacle, North Carolina, passing the time of day with James Harold Jennings; or up in Snaky Holler, Nada, Kentucky, exchanging jokes with that fine carver, Carl McKenzie. Or down in desolate South Georgia, looking at the few remaining sculptures of Miss Laura Pope.

And this (my consistent agoraphobia in the face of commercial competition and establishment privilege) is why The Jargon Society came to publish Ernest Matthew Mickler's unabashed and unbuttoned classic, *White Trash Cooking*. The late Senator J. William Fulbright, of Arkansas,

commented: "The French and Italians, aside from the peasants, can't begin to compete." I no longer desire the *grand luxe* of three-star cuisine, though to be fair, if someone invited me to dine at Firmin Arrambide's two-star Restaurant Les Pyrénées in St. Jean-Pied-de-Port in the French Basque Country, I would certainly accept for a plate of his famous Biperrak Makallaoz Beteta (Peppers Stuffed with Salt Cod), washed down with the Irouléguy wine from down the road. Jean-Pierre Xiradakis, the famous chef-owner of La Tupiña, in Bordeaux, makes a wonderfully clear statement: "I started La Tupiña back in 1968 to offer the food my mother and grandmother cooked when I was a child. What I do, anyone could do — it's nothing refined and not very fancy. But this is the way we eat in the countryside. It's *de la bonne bouffe* — 'good grub.'"

So, finally, what we have here is a "Home-Made World," to use Hugh Kenner's term. I've tried to heed Joel Oppenheimer's injunction: "Be there when it happens, write it down." People peering in here must take my hand and follow my lead into a lot of new territory — or, go back to MTV. The Great Unwashed will not dig this stuff at all. However, I do not write for The Great Unwashed. I write for them that wants it. And that ain't all that many. Can I tell my excellent publisher stuff like this? I can only hope that we find 5,000 to 10,000 illuminati who like it enough to buy it. This reminds me, somehow, of an Oscar Wilde anecdote that is not often told: Mr. Wilde was taking tea at the house of a matron in Chiswick, West London. The ten-year-old daughter entered the room and the mother said, "Sabrina, do play a little piece at the piano for our distinguished guest." The child sullenly delivered a wretched rendition of "Chopsticks." Her mother continued: "I suppose you do love music, don't you, Mr. Wilde?" "Not at all, Madame — but I like *this*." We meander on. Where, who, or what will demand my next photograph?

I dedicate *A Palpable Elysium* to the incomparable (and mysterious) Thomas John Meyer — essential companion over 32 years. And to certain saplings in the orphic groves and erotic thickets who like the way we do things: Michael von Üchtrup, Michael Heny, Anne Midgette, Reuben Cox, Gregory Hays, Jont Whittington, Greville Worthington, Alex Albright, Jim Cory, C.A. Conrad, Jeffery Beam, Mark Roberts, Keith Hale, Wendy Kramer, Ricky Garni, Tim Davis, Thomas Evans, Jeff Clark, Warren Liu, Matthew Stadler, Brian Mackenzie, Whit Griffin; and to all those gentle, mature trees who still "abide" hereabouts: John Claiborne Davis, Robert Peters, Jess, Charles Henri Ford, Georgia Blizzard, Lou Harrison, Nancy Metcalf, Joan Wilentz, Harold & Mary Cohen, and many way on down. And to our most excellent cat, H-B Kitty (aka Orange Doodle, The Marmalade Meatloaf, Long Cinnamon and The Terror of Tiger Woods).

Pass the biscuits — and do hush!

JW
Skywinding Farm, Scaly Mountain, North Carolina
8 March 2002

KENNETH REXROTH
(1905–1982)

KENNETH REXROTH could be scabrous, scurrilous, serene as Li Po on a moonlit creek, and gloriously funny — often, all at once. I remember visiting him one afternoon in the early fifties in San Francisco out on Eighth Avenue. He was, obviously, in something of a state. Black Mountain College had just sent a quite distinguished representative to his apartment to try to tempt him into a residency at the College, but she was (1) not interested in his amorous blandishments; and (2) made the mistake of asking as she looked in the front hall: "Oh, Mr. Rexroth, do you paint?" To which he wickedly replied: "Gosh, no, girl, of course not, my cheeks are just naturally ruddy." He later referred to this well-meaning soul in a memoir as "that frigid, dirty-pantsed nymphomaniac."

Well, macho he was. But life is often quite confusing and nobody is 100% *anything*. Someone once asked Tallulah Bankhead if Montgomery Clift was queer. She replied: "I don't know, darling, but he never sucked *my* cock."

Kenneth would say things like: "Most poets were little boys who couldn't play baseball or ride bicycles. So, the big boys got them down in the vacant lot, rubbed sand on their thing, and they eventually took to art." He was very proud of his skills as an outdoorsman and insisted that, if dropped by parachute over any terrain in the world, he would have the resources to survive. *Self-reliance*, he used this word all the time — it's not a bad idea, considering the scissorbills and buttholes who surround us in the dark republic.

He said: "90% of the worst people I know are poets. Poets these days are so square they have to walk around the block just to turn over in bed."

He said: "98% of American poets don't exist. They are androids created from Randall Jarrell by the lost-wax process."

He said: "There is no place for a poet in American society. No place at all for any kind of poet at all." This was in writing about a poet of vision he always espoused vigorously: Kenneth Patchen.

Yet, he was also capable of saying: "Man thrives where angels die of ecstasy and pigs die of disgust. The contemporary situation is like a long-standing, fatal disease. It is impossible to recall what life was like without it. We seem always to have had cancer of the heart."

I loved his company on hikes in the state parks of Marin County. He knew the names of everything. He seemed to have read about as much as Thomas Carlyle, the last literary man who claimed he had read absolutely everything of the slightest importance. He was a fine cook. He dressed in a resolutely old-fashioned, bohemian way. I had two walking suits made by his tailor in Southampton Row, London. The Harris and Donegal tweed is intact after 35 years and they still fit me, courtesy of all those thousands of miles afoot.

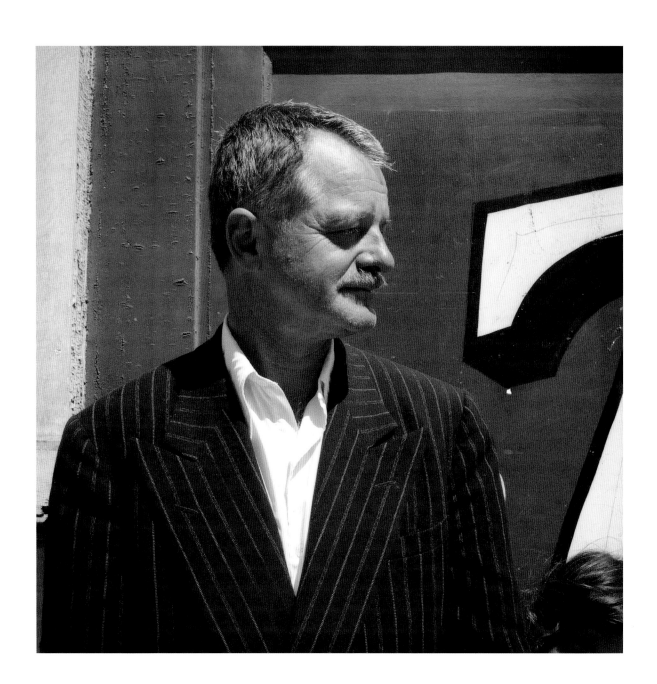

The suit he is wearing in the photograph I took of him in San Francisco in 1955, he claimed, was given to him by Al Capone. Yes? No? It doesn't much matter. He was was one the finest men of letters the country has ever produced and it is sad how few Americans in 2002 have even a clue about this fact. His books are there to verify it.

Paul Carroll tells us a nice little story. James Wright, the poet, was sitting in Daddy Waxwrath's parlor (that's what Robert Duncan and Jack Spicer and Jimmy Broughton always called KR) way back when. Jim asked: "Kenneth, *why* do you write?" KR shot back: "To overthrow the capitalist system and to get laid — in that order." *Laus Deo!*

JELLY ROLL MORTON
(1890-1941)

IT'S ABOUT 17 YEARS since the composer, Alden Ashforth, and the viola da gamba (or, was it, the viola d'amore?) player, Steve Teeter, led us on a pilgrimage far into East Los Angeles to find the grave of the incomparable Ferdinand "Jelly Roll" Morton. We had been told of its whereabouts by Tim Fitak, a jazz fanatic I've lost complete track of, so I can't be more precise with the exact location. (Always carry a notebook!) And I remember another cemetery, nearby, with the monument of the clarinetist Jimmy Noone, of Cut-Off, Louisiana. (Mezz Mezzrow asserts that Maurice Ravel came into the Apex Club in Chicago one night to hear Jimmy. "Amazing" he said over and over to the first clarinetist of the Chicago Symphony Orchestra, who said "Incredible" over and over in response.) Buried nearby: the great Johnny St. Cyr (guitar and banjo). And, if the memory's not deceiving me: also the grave of trumpeter Papa Mutt Carey, he who was memorable for *Tiger Rag* performances with Kid Ory.

Jelly was a roilsome and complicated character, one of the greatest pianists and composers in jazz history. He even claimed to have invented "jazz." He was proud of his French antecedents and was not happy to be considered merely black. The last time I talked to the wonderful Bill Russell, early percussionist composer, and, later, major archivist of what he simply called "American music in New Orleans," he was trying to finish a biography of Jelly. He said he was pretty certain that Morton *père* was Jewish. Now, that certainly thickens the plotnik and adds extra filé powder to the musical gumbo.

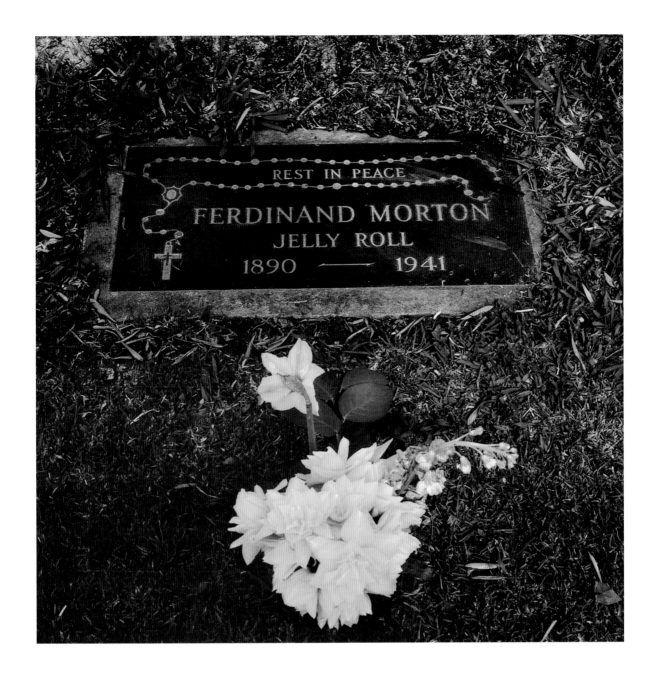

EDDIE MARTIN,
"TWIXT THE LIGHTNING AND THE MOCKING BIRD"

THE SIGN SAYS: BAD DOGS! BLOW HORN STAY IN CAR TIL I COME OUT! Eventually, Mr. Eddie Owens Martin, St. EOM, the One & Only Mystic Bad-Ass of Marion County, Georgia, will bellow like Proteus and emerge in ceremonial drag through the sculptured, Easter-Island-like gates of the Land of Pasaquan ("where the past and present and the future and every-thing else meet") and check against any "bad viberations." Most quivering supplicants want to avail themselves of EOM's psychic powers: he reads cards at twenty bucks a throw. "The white folks are interested in bullshit; the black folks want the lucky number . . . I like about five cus-tomers a day, that gives me room to maneuver . . . Most of them are caught in the love-trap, man, the LOVE-TRAP! Back in the old days, a man would just want to get his rocks off. Now he says: LOVE ME! . . . Shit."

Well, there you see him, the Saint Himself — and, indeed, he was a very saintly person (the one and only saint of his very own one-man religion). He'd done all the bad stuff, eaten it for breakfast, spit out the seeds, and come through totally radiant on the other side. There are his faithful old Alsatians, Boo & Nina. All are now gone. EOM put a pistol to his head on April 16, 1986, when he was approaching 78. He was used up: bad kidneys, no prostate, very little heart. He had little heart for the evils of modern America — "they'll ostracize the shit out of you every way they can."

The Land of Pasaquan is as cosmic as the Ideal Dream Palace of the Postman Cheval in the Rhone Valley; or Simon Rodia's Towers at Watts, California. Where is it? Find the post office in Buena Vista, Georgia, which is maybe 25 miles southeast of Columbus. Go north on Highway 41. In about a mile, veer left on Highway 137, towards Cusseta. Three more miles, take the second paved right, just before you get to Kinchafoonee Creek. Go about a half mile, and where you see cane and bamboo, angle off right onto a dirt driveway. There, just like in The Wizard of Oz, sud-denly everything turns Technicolor.

One hot afternoon St. EOM was rared back in his rocker on the porch, helping digest his col-lard greens and cornpone with a huge joint of fine "donkey-dick sensa," about the size of a Hav-a-Tampa full corona. "Pasaquan is a monument to me and my mother. I am the first martyr to Pasaquoyanism. I am a Prophet without profit. It's a bitch, man. Everything's cotton, corn, and peanuts around here. People wouldn't know art if it bit 'em on the ass."

I once asked him if there were any commandments or prohibitions in Pasaquoyanism. He shook his beaded and be-turbaned head: "Wear your hair straight up. Do what you like. Screw who you want. Don't hurt nobody. Just act natural, man . . . It means the end of all these Buddhists and Muslims and Christians and all this other shit, man. I just hope I live long enough to establish it."

A holy place like Pasaquan is always at great risk from rednecks and predatory nature. A membership in the *Pasaquan Preservation Society* (PO Box 5675, Columbus, Georgia 31906) is warmly suggested. All that housepaint costs a lot of money. Write for membership information. There are levels from $10.00 to $5,000.00 (or more). The Director, and the great champion of Pasaquan, is Fred Fussell, former director of the Columbus Art Museum. You may also phone him for information at (706) 327-8789.

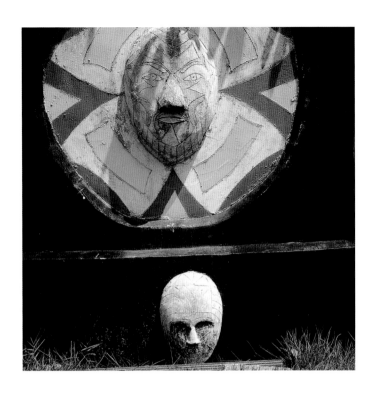

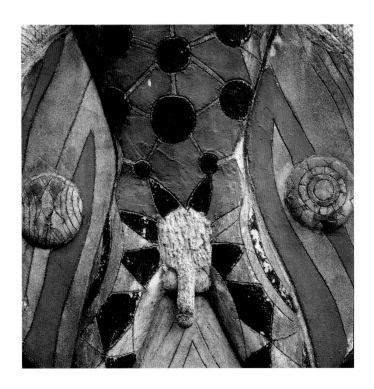

TERRA-COTTA WORK AT THE ENTRANCE OF
LOUIS SULLIVAN'S GUARANTY BUILDING,
BUFFALO, NEW YORK (1894–95)

"...SULLIVAN'S EXAMPLE was natural growth in trees and leaves — natural, too, as Whitman found animals, because the tree is not 'dyspeptic with introspection.' He demanded similar spiritual, living results in building, and he insisted that they could only spring from the life of the architect: 'On no other basis are results of permanent value to be attained.'"

— SHERMAN PAUL, in *Louis Sullivan: An Architect in American Thought*

"The ornament, as a matter of fact, is applied in the sense of being cut in or cut on or otherwise done: yet it should appear, when completed, as though by the outworking of some beneficent agency it had come forth from the very substance of the material and was there by the same right that a flower appears amid the leaves of its parent plant.

"Here by this method we makes a species of contact, and the spirit that animates the mass is free to flow into the ornament — *They are no longer two things but one thing.*"

— LOUIS SULLIVAN, in *Ornament in Architecture*

"There stands at Buffalo, for example, the noble Guaranty Building, later called the Prudential, built in 1894–95 when Sullivan stood at the summit of his practice. A giant in scale, if not in size, it stands amongst masonry and steel-borne buildings, many of which tower above it, but it alone is memorable because it alone allowed its purpose to organize its mass, to suggest how steel and bronze and terra cotta might cease being inert and spring into life.

"For anyone who has ever seen it, except regrettably for the men of Buffalo who have progressively defaced it, the Guaranty Building is the consummate statement of America's first urge to give appropriate, beautiful shape to the environment of industrial society. It resolved the plaguing schism in nineteenth-century attitudes, where the raw world of science, industrial technique and commercial enterprise stood across the tracks from the world of culture, a world of imagination and spiritual ideals shamelessly cloaked in the Gothic and Classic mantles reserved for churches, museums, and universities.

"Sullivan resolved the dualism; he united utility with beauty in the service of a modern institution. His inspiration arrived in a pasture with an elm tree; its realization came at Buffalo, when Louis Sullivan was 39."

— ALBERT BUSH-BROWN, in *Louis Sullivan*

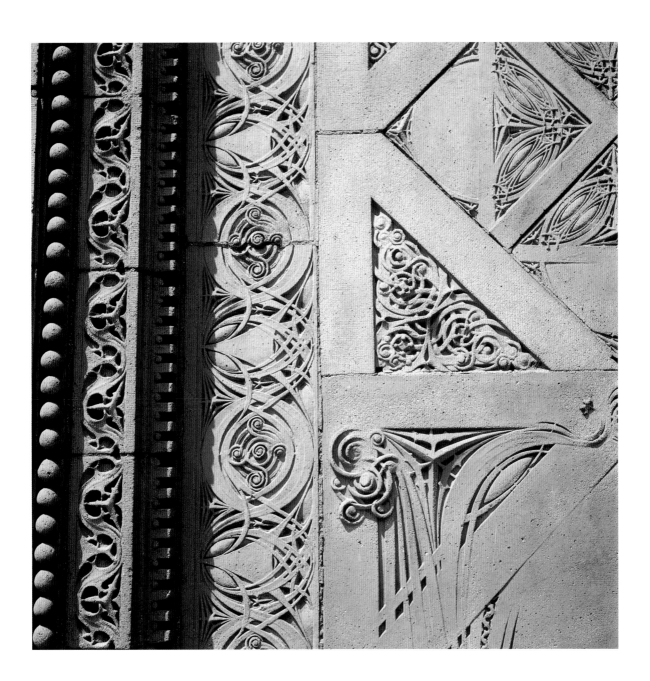

THE GRAVE OF KENNETH GRAHAME
(1859–1932)

BEHIND ONE OF THE OXFORD UNIVERSITY COLLEGES. What can one say? My father, not the most literate of Southern men, was literate enough to read aloud to me, at age six, such writers as Grahame, and Hugh Lofting (*Dr. Doolittle*), and Kipling (*Just So Stories*). And, even more importantly, for a curious southern child with a taste for ribaldry and wit: Joel Chandler Harris (*Uncle Remus*) and Roark Bradford (*Old Man Adam and His Chillun* and *Old King David and the Philistine Boys*), plus the dialect poems of the North Carolinian, John Charles McNeill. Thus, I had "lingo" in my head at a very early age, which was only increased by RADIO. All those wondrous programs like "Let's Pretend" and "I Love a Mystery" and "The Hermit's Cave" and "Jack Armstrong, the All-American Goy." Nothing to do with Herr Disney and TV. It remains a singular watershed that I defend proudly.

Mole and Ratty and Badger and Toad stay absolutely in my head. Aye, all these comfortable, South-of-England, civil male companions. To be followed by Superman and his side-kick (am I getting confused — was it only Lois Lane in his case?); Batman and Robin, the Boy Wonder. A lot of us crawled out of fundamentalist ooze and went happily queer on that noble diet of Bruce Wayne and his "ward," Dick Grayson. Oh, to live in the back of the sweaty Batcave and the back-seat of the Batmobile!

As for *The Wind in the Willows* — the prose in the chapter, "The Piper at the Gates of Dawn." Heady, heady stuff for young, panting American guys with little preparation for the great god, Pan. Thank you, Kenneth Grahame! One supposes that the likes of Senator Jesse Helms never had the North Carolina training I did. Thank you, father, Ben Williams!

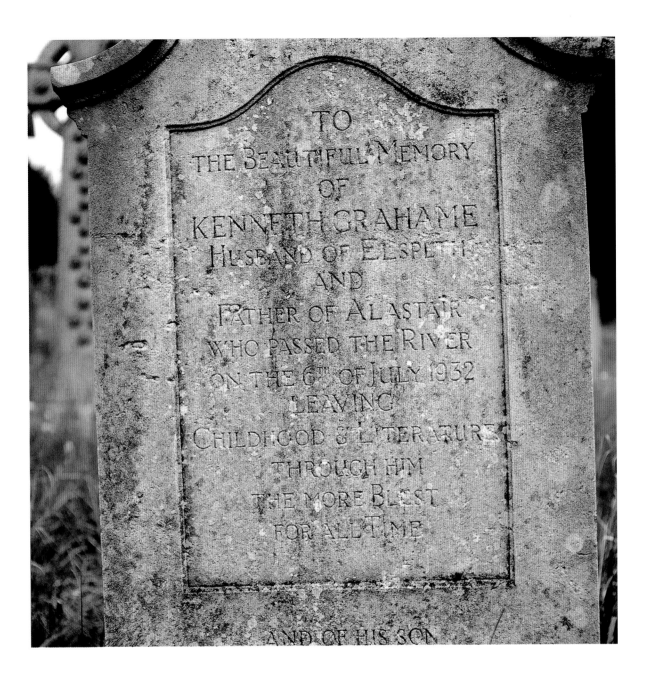

TO
THE BEAUTIFUL MEMORY
OF
KENNETH GRAHAME
HUSBAND OF ELSPETH
AND
FATHER OF ALASTAIR
WHO PASSED THE RIVER
ON THE 6TH OF JULY 1932
LEAVING
CHILDHOOD & LITERATURE
THROUGH HIM
THE MORE BLEST
FOR ALL TIME

AND OF HIS SON

FATHER THOMAS MERTON
(1915–1968)

Tom outside his hermitage in the woods at the Abbey of Gethsemane, Kentucky, back in the middle 1960s — seen in the manner of 13th-century Sienese painting, or am I just making that up?

Trappist and Catholic I ain't, though we got on very nicely. I used to send him a lot of current poetry books, *some* of which the Abbot let him see. I also used to bring him a supply of Christian Brothers brandy to hide under the porch. A genuinely nice (secular) man, so excuse me, please, if I don't feel prepared to go on about the spirituality, etc. Dozens of people have gone on, and continue to go on, about that. I introduced him to people like Guy Davenport and Ralph Eugene Meatyard and they made his life much jollier there in the western Blue Grass. One gives what comfort one can. If one *can* be useful, maybe that's about enough? The most important thing is kindness, said Mr. Henry James. And the second most important thing is kindness. And the third most important thing is kindness . . .

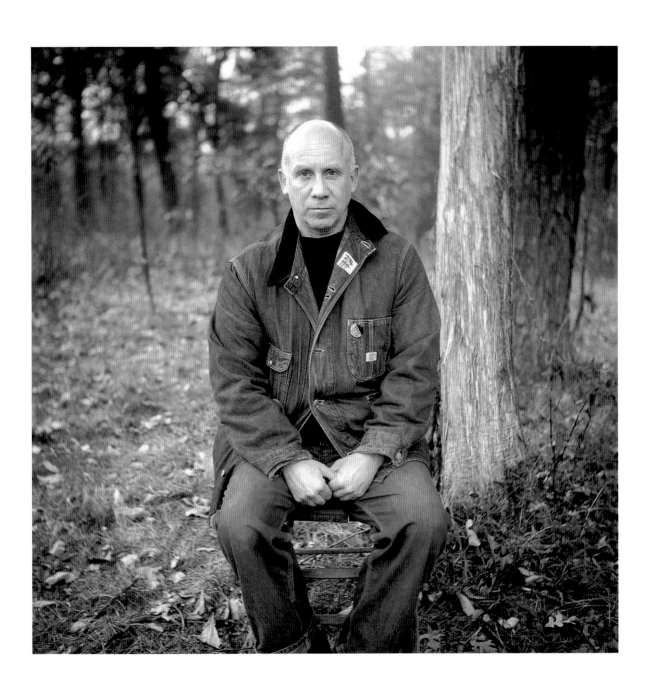

THOMAS JOHN MEYER
(1947—)

HERR DOKTOR PROFESSOR CARL JUNG goes on at length about the *Puer Eternus*, and if Tom ain't the *Puer Eternus*, who the hell is? Even a dumb hillbilly sensualist like me could figure that out. This photo is at Penland School, Mitchell County, North Carolina, winter of 1969, shortly before which we began sharing our lives. A remarkable poet; a fabulous translator of Middle English, Ancient Greek, Hebrew, Old Chinese, Sanskrit, on and on. A unique amanuensis. Famous cook, famous companion. Without his benign presence I would have been able to accomplish about 17.6% of what I have done over all these considerable years. Nowadays he is also an Ayurvedic Astrologer and more mysterious than a tramontane personage like myself can always quite fathom. But, no real problem. I don't like to presume to know too much. His latest book is a New & Selected Poems called *At Dusk Iridescent*, with a very beautiful Mark Steinmetz photograph on the cover. If there were more and better readers, his craft would be marvelled.

ROBERT KELLY
(1935—)

A JACKET-FLAP from ten years ago tells us: "RK was born in Brooklyn on September 24, 1935. He attended CCNY and Columbia University, and since 1961 has taught at Bard College. Forty-two volumes of his poetry have appeared, the major collections published by Black Sparrow Press, including *Kill the Messenger Who Brings Bad News*, which received the *Los Angeles Times* Book Award in 1980. Kelly has also been Poet in Residence at California Institute of Technology and Tufts University, and presently he directs the writing program of the Milton Avery Graduate School of the Arts, Bard College." Robert is more eruptive than any volcano you can think of. I can imagine getting swept away in the lava of his word-flow. What a notable number of young poets have benefited from his knowledge and attentive counsel — including Tom Meyer.

Large, voluble, amiable Irish gentlemen like Robert Kelly (trained ba-goom by Jesuits) and Charles Olson have always made me fret over W. J. Cash's assertion in *The Mind of the South* that Southerners actually had *no* minds and made it hard for me to read their more arcane works without feeling seriously inadequate. He has read so much and absorbed so much, simply being the ample epiphyte in the atmosphere of the culture that he is, one hesitates to tell him anything without feeling he knows it or has heard it already.

Which isn't really true and ignores his extreme sociability. He is as happy talking about Dr. Strange-Glove, Space-Man, Long-Tater, Oil-Can, and other eccentrics of the Boston Red Sox as about some of the minions of H. P. Lovecraft's Cthulhu Mythos: Shub-Niggurath, Nyarlathotep, Azathoth, the Dholes, the Fungi from Yuggoth, and Kindly Old Yog-Sothoth himself. Great Old (and I mean old!) Guys, when you get to know them. And Robert is as happy to discourse on Spike Jones as much as on Karlheinz Stockhausen. As they say down here in the Blue Ridge: "They . . . Lord knows, God done throwed away the pattern after He made that boy." *Salut!*

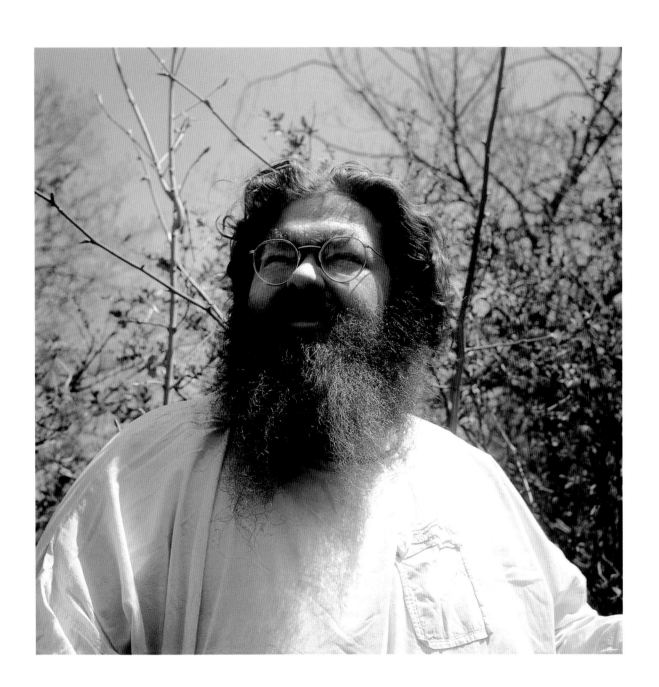

ERIK SATIE
(1866–1925)

Satie lived in a socialist, working-class suburb south of Paris called Arcueil. I remember photographing his grave there in 1966 the afternoon when England and Germany were playing a famous World Cup Championship football match (which England finally won 4–2 in overtime, with Bobby Charlton leading the charge). A recent informant absolutely assures me that Constantin Brancusi carved the letters on his stone. Somehow, that looks and sounds right.

He is an "exquisite," The Velvet Gentleman, a composer that one demands on certain occasions when no one else will do. A lot more could be said, but I am not the one to say it. Check him out in the pages of Virgil Thomson, Roger Shattuck, John Cage, and Wilfrid Mellers.

When Milhaud and (I think) Poulenc went to his rooms after his death, the most wonderful thing was under the bed was all of his correspondence. He had opened not one letter in 25 years. Who needs *worldly?* Worldlies, leave this poor man alone!

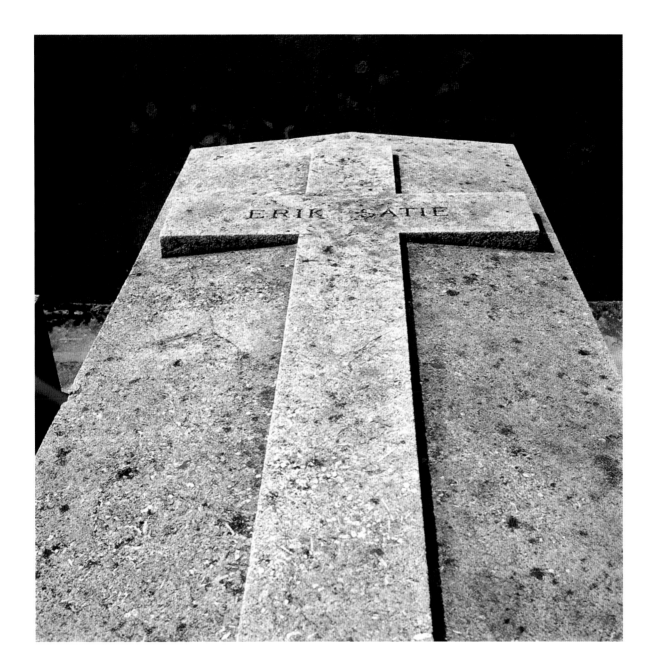

HARRY PARTCH
(1901-1974)

I MUST HAVE MET HARRY PARTCH IN 1959, in New York City. The meeting had something to do with Ian Hugo, Australian film maker, one of the various husbands of Anaïs Nin. Henry Miller must have instigated that contact — I don't remember much about any of it. Anyway, we were instantly friends and I invited Harry to North Carolina and he came down and lived in Highlands for a couple of months in the summer and stayed in the family guesthouse. The stone terrace he built back of the main house is still there in the woods under the oaks and hemlocks. We took him one night to hear country music in the courthouse over at the Macon County county seat in Franklin. He hadn't ever seen clog dancing before (of the Appalachian variety) and thought it was great.

He introduced cloggers into one of his big premieres at the University of Illinois, Champaign/Urbana, in the middle sixties: *Revelations in the Courthouse Park*. I remember managing to drive there for the first performance, all the way from Fort Collins, Colorado, after a poetry reading, despite being marooned overnight in a spring blizzard in the quaint little town of Funk, Nebraska. I said prayers to Charlie Mingus, got up very early, and slipped and slid eastwards, barely in time. People like Peter Yates and Gil Evans had come from both coasts for this rare occasion.

My training in music isn't sufficient for me to elaborate on his scale, his 44 tones to the octave, or his approach to intonation. If you have ears for Ives, Ruggles, Henry Cowell, Henry Brant, Colin McPhee, and Lou Harrison, Partch belongs there too. I love the sound of his homemade, heroic instruments and the extraordinary look of them. And the names! The Spoils of War, The Blowboy, The Double Canon, The Giant Kithara, The Marimba Eroica, The Diamond Marimba, The Chromelodeon . . . He was a gentle, passionate, complicated, warm maverick of a man. It's fitting that his cousin VIP (Virgil Partch) was a fine zany cartoonist of the time. Harry ended his years in southern California and we somehow lost touch.

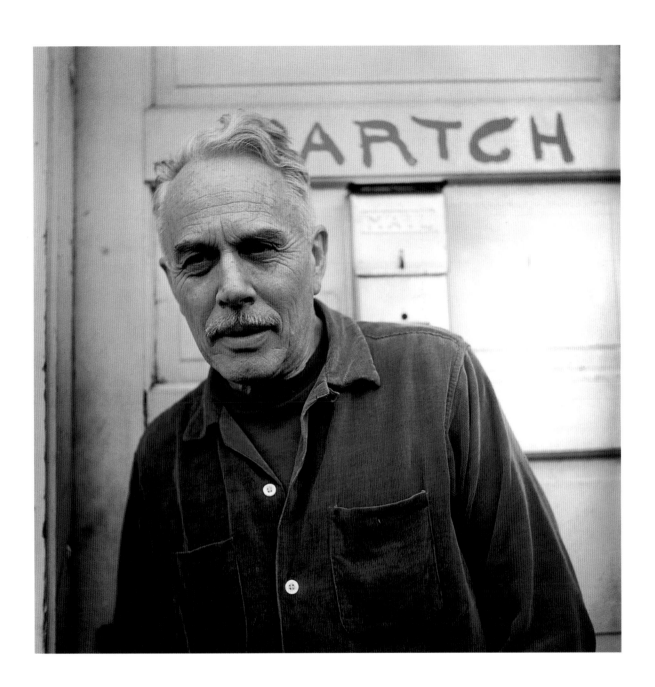

BOOKER TELLEFERRO ERVIN & KENNETH PATCHEN

BOOKER ERVIN (1930–1970) played tenor sax for Charlie Mingus's Quintet in 1959. He came out of Texas and his tone hit you like a Mack truck. He and Eric Dolphy were my favorite horn men of the time. I spent most of my evenings at the Half Note down on Hudson Street in New York's Greenwich Village. Large Charles Mingus was playing his ass, on both mouth and bass. One simply knew these were classic occasions in jazz history. Booker died much too young of a kidney ailment. Somewhere amongst my LPs is a great one, *The Book Cooks*, and several of the series he did for the Prestige label: *The Blues Book, The Song Book, The Freedom Book.*

Kenneth Patchen (1911, Niles, Ohio; 1972, Palo Alto, California) came east from California that spring (1959) to do several jazz-and-poetry sessions with Mingus at Julian Beck and Judith Malina's Living Theatre. He was one of our greatest naturals — like Babe Ruth, he must have come down out of a tree — a poet and man for whom I had all kinds of time. I started reading him in prep-school and, as they say, "he changed my life." I knew him well over 15 or 20 years; I published three of his books. I wanted to do much more, but none of us ever had enough money. The unabashed young used to know him and love him. Now they don't. I don't know if they know anything or anybody with that measure of visionary fire. As a perceptive writer in Philadelphia wrote me today: "The young suck. People now are horrible, but poets are worse." Patchen used to bewail "beings so hideous that the air weeps blood." I'm afraid he got it just right.

New Directions has always been very faithful to Patchen, whether he sold or not. Check it out. Help Save The Real American Community! Very small, but still there under all the crap.

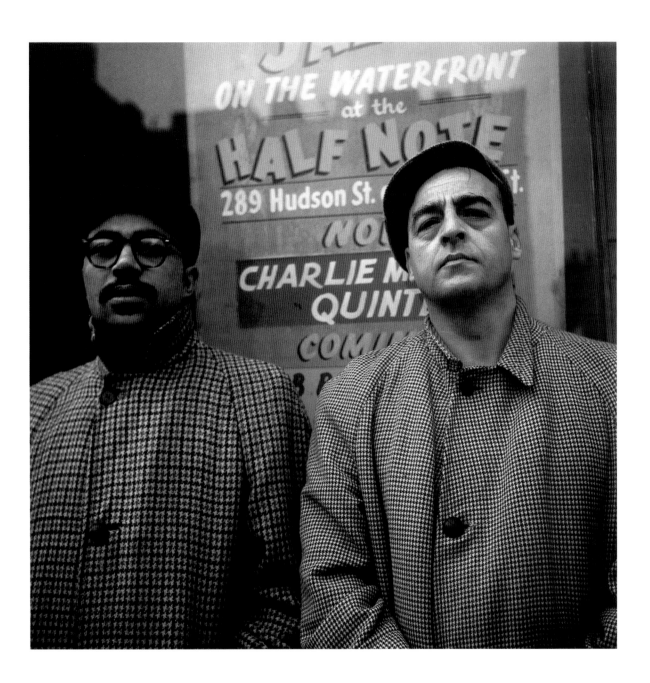

HENRY MILLER
(1891–1980)

TIME GAVE MILLER'S *The Air-Conditioned Nightmare* a hideous review when it was published in 1944, so I rushed down the hill to Dupont Circle in Washington, DC, and bought it from the estimable bookseller, Franz Bader. I was a polite schoolboy at St. Albans School at the time. (I still am, in certain ways.)

I went to visit HM on Partington Ridge, Big Sur, California, in June, 1951, a month before I went to Black Mountain College. He was completely avuncular, funny, enthusiastic, supportive. I never knew him very well (though I still somehow managed to beat him in ping-pong on a few occasions — it was like beating Proteus!), but published his *Red Notebook* and enjoyed his company and his great American sass. His voice was just like that of Pete Smith in the movie short-subjects — a Brooklyn boy.

I don't read him much these days but, now and then, look into his charming essays on people like Jean Varda, Ephraim Doner, Kenneth Patchen, Michael Frankel, Jean Giono, Beauford DeLaney. He loved books and rare individuals as much as any man I've ever known. Blessed be his name! I'm not really bothered whether he was great or whether he wasn't great. He was a mensch!

In a little tract called "The Plight of the Creative Artist in the United States of America," Henry Miller said: "I have tried more perhaps than any other living writer to tell the truth about myself . . . I don't say that I have succeeded — but I have tried." Elsewhere, he noted: "My earnings were just about sufficient to keep a goat alive."

CLARENCE SCHMIDT'S
OHAYO MOUNTAIN ENVIRONMENT

By the time I got to Clarence Schmidt's place on Ohayo Ridge above Woodstock, New York, his big seven-level house had burned and much had been totally lost. I found Clarence one day in the Silver Forest, smearing aluminum paint on the lower limbs of any and all trees and saplings at hand. It would have been November of 1969.

He had been making a series of shrines, many having to do with presidents of the United States. Here you have George Washington's. He started with a photograph, which he would then protect with varnish. "It takes on a pretty effect. A sort of antique effect. Cured. This is a curing process. The stuff that I put on bleeds within this material, and as the years pass by, it becomes antique, like an oil painting." By 2002, Mr. Washington probably looks like Dorian Gray.

Gregg Blasdel had some great conversations with Clarence and recorded them in his book, *Clarence Schmidt*, published by the Robert Hull Fleming Museum, University of Vermont, 1975.

"To tell you the honest truth, I've got more art here than in the entire country."

"I'm a cross between Rip Van Winkle, Paul Bunyan, and there's a lot of Robin Hood in me. I became some greater part of this mountain up here. Why, when I walked along the road, the trees bent down on my behalf."

"They used to say Clarence has gone crazy up there in the Catskill Mountains. He's just there to finish another stucco. Do you know what he does? He takes that black tar and this solemn looking stuff and he stands about ten feet away from the building and he starts throwing cracked glass on it and singing 'My Old Kentucky Home.'"

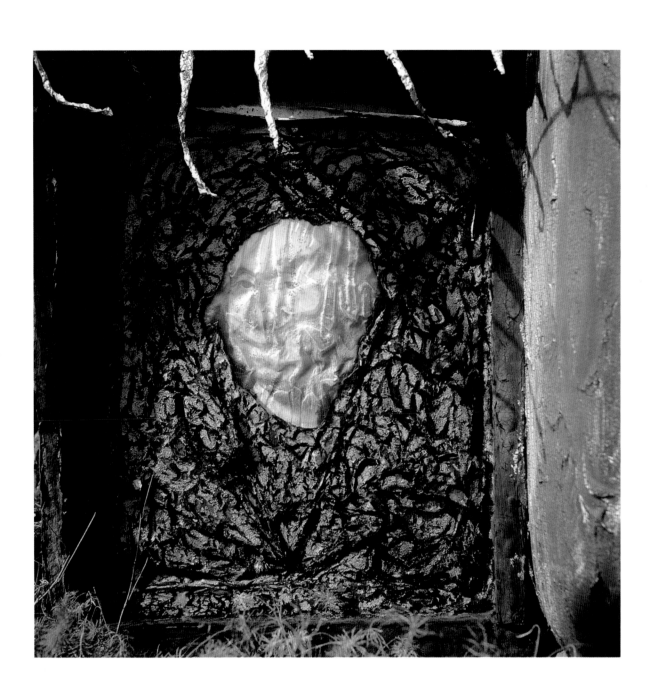

THE ART WORLD OF JAMES HAROLD JENNINGS

On Spainhour Road in rural Stokes County, North Carolina, about 25 minutes north of Winston-Salem on the way to Pilot Mountain, you will suddenly encounter on the right-hand side a cluster of decrepit, never-to-move-again, orange school buses. Every day, including Sunday, you will find the Artist of the Sun, the Moon, and the Stars, always at home and hard at work, cutting up plywood and painting it, making his unique pieces. James Harold's constant companions are ten or so cats. He used to live across the road in the old family house. He just tore it down. Now he chooses to live in one of the buses, that way the cats don't have to cross the road and risk getting killed by the car jockeys who roar by.

James Harold, who must be in his late sixties by now, tells his visitors that he enjoys living "kind of low," like the Amish people, in the old style. He has no running water, or electricity, or car, or telephone, or e-mail, or T V. He sleeps on a pallet in one of the orange buses, upon which he un-rolls an old sleeping bag. He goes to bed when it gets dark and gets up when it's daylight. He has a kerosene stove on which he prepares his simple meals. He likes country salt-cured ham, pinto beans, vienna sausages, saltine crackers, canned chicken and dumplings, and coffee. I imagine he makes a little cornpone now and then in the skillet. While he works outside on his art, he listens to country music and to police reports on his radio, smokes Hav-a-Tampa cigars, and savors a few Miller Sandwiches. "'Miller Sandwiches' — what are those, James Harold?" "Boys, that's when you take two Miller beers and put a third in between 'em."

I would venture to say he is one of the most charming and delightful artists in the world. I have, more or less, worn out Joan Miró, but not Mr. Jennings. He loves company. If you go to see him, be nice and take him some decent cigars and better beer than he's used to. He votes Republican but doesn't like George Bush and mean old Jesse Helms. He's afraid the Democrats will ban all tobacco products — and in what else can a poor man find enjoyment but a smoke and a beer or two or three?

What does he make? Brightly colored scrap-wood constructions painted with enamel and day-glo latex. Some are Ferris wheels, some are whirligigs, some are like shooting-gallery con-structions, or billboards, or Burma Shave signs, or tableaux, featuring processions of pussy cats and dinosaurs, rough-tough women beating on little male bullies and devils. Though he only went through fifth grade, James Harold is a prodigious reader. He has stacks of *Popular Mechanics* and *National Geographic* magazines. Plus books on astral projection, electroencephalography, and metempsychosis — "them's dictionary words, boys."

"What truth there is in the Bible is astrology. You can get down on your knees and pray for what you want to, and, if it comes, it comes, but it won't come from God."

"I believe in the Goddess. I'm not sure which one. It might be Diana, the Roman moon goddess; or Lilith, the mythical creature who preceded Eve in the Garden of Eden."

"Well, boys, you know there's a whole lot of company in what I do. I never get lonely . . . That's because my art is somethin' they call visionary art. Ain't it been hot this time? I'm looking forward to when the leaves fall. These Republican politicians are making it hard on art."

Coda: A sad end to all this. Early on the morning of April 20th, 1999, his 68th birthday, James Harold put a pistol to his head and shot himself. His sister-in-law, Normie Jennings, tells me that recently he was being treated for depression and was taking medicine. He seemed very nervous and agitated by the forthcoming Millennium, and afraid that vandals and lawless mobs would come and wreck his Art World. It was William Carlos Williams who said that "the pure products of America go crazy." No longer true. Half the people you see today look scary — on television, at the mall, or driving around like bats out of hell. And there are 250,000,000 hand-guns in the USA, at least one for every citizen.

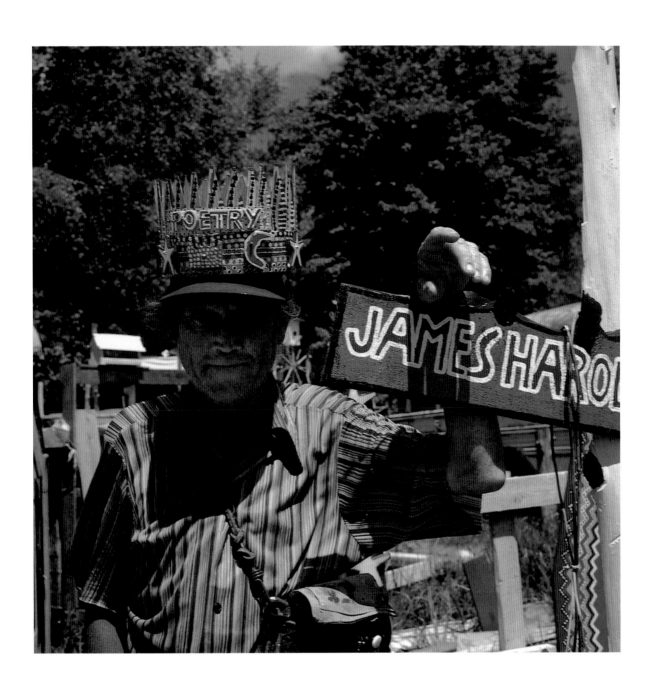

ROBERT DUNCAN
(1919–1988)

HERE IS RD IN THE INDUSTRIAL WILDS of San Francisco's Mission District in the spring of 1955. Things there, as you can clearly see, had an occult habit of looking very much like paintings by Clyfford Still.

Let's best leave the Great Poet stuff well alone. For us deprived and isolated Americans, was he the Apollinaire *de nos jours*? The Satie? The Dante? The Goethe? We tend to over-estimate ourselves, we democratic poets with so little power of any kind. Robert Duncan was certainly as good a phantaste and romancer as Gabriel Fauré — there is nothing wrong with that, though perhaps only 59 persons in the world knew enough to listen for his angelic whirrings.

Duncan was born in small-town Bakersfield, California. He enjoyed being a sage and a mage. He could outtalk R. Buckminster Fuller and the Wicked Witch of the West put together. Samuel Taylor Coleridge might have found himself gasping for air and being swept away by this river of sacred conversation.

It needs to be said that Duncan was the absolute master of the campy imagination. Other-wise, the academic and boring straight-arrows will suddenly try to claim him for their own and startle us with the revelation that Mr. Lowell was not the only Robert around. In fact, they paid him little heed. And still don't.

Another thing about Robert Duncan; he was was the bard of gay domesticity. Most of our poets are company men (Corn-Belt Metaphysicals from Iowa; Ivy-League Society Late-Bloomers; and West Coast Stoned-Age Toughs). It's hard to think of anyone further from all that dreck than RD.

When I visited him in 1954 in San Francisco, he was the first person I knew with *The Lord of the Rings* high on his shelves. He loved the Edith Sitwell of *Façade*. He loved Lotte Lenya's singing of the Berlin and New York theatre songs of Kurt Weill. He loved George MacDonald's *At the Back of the North Wind* and *Lilith*. He was the first of my friends to recognize the special genius of Louis Zukofsky, and of the Scots poet, Ian Hamilton Finlay. We shared tastes on the margins of Ameri-can culture: Randolph Bourne, Edward Dahlberg, Bruce Goff, Enid Foster; and, of course, Jess Collins, the astonishing visionary artist who was central to RD's life for over 37 years.

Christmas morning, 1954, there was an early knock on the door of my little railroad flat back in a garden in the San Francisco Marina, near Fillmore and Filbert Streets. I got out of bed and opened it. There was Duncan, who said in his charming, walleyed way: "Well, here I am, I'm your Christmas Present." What do you say to that? Mages do what they do.

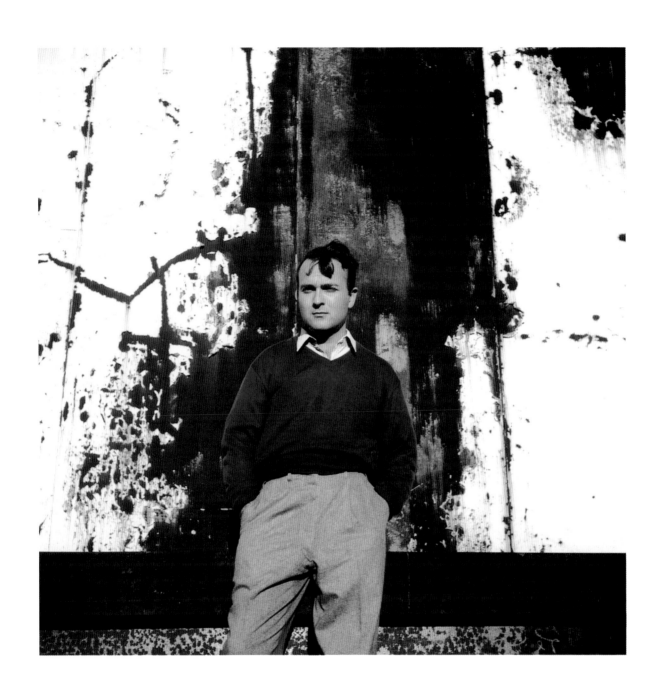

JESS — AND A WIDER LOOK AT THE CLYFFORD STILL EFFECT
(1923—)

JESS'S CHILDHOOD NAME was Burgess Collins. He was born in Long Beach, California. His educational interests were primarily in chemistry. At one point he monitored the production of plutonium at the Oak Ridge atomic-energy laboratories in Tennessee during service with the Army Corps of Engineers. In 1949 he heard Robert Duncan read poetry in Berkeley. Jess dropped out of graduate school at the University, moved across the Bay, and began painting studies at the California School of Fine Arts, studying with Clyfford Still, Edward Corbett, Hassel Smith, Elmer Bischoff, David Park and others.

Back in the fifties Jess lived with Duncan in San Francisco and Stinson Beach and worked in a pharmacy to help support their household. He cooked beautifully, fixed the lamp switches, repaired the furniture, established an order and held their lives together. (Robert Creeley dubbed him "The Happy Undertaker," such were his quiet, amiable reserve and his gray-suited attire.) He was an artist, but not one many of us thought all that much about. Stupid us. Since then, he has transformed himself into a world-class master. Let's bring up names like Gustave Moreau and Max Ernst and Balthus. His recent retrospective at the Whitney Museum in New York (1994) makes such comparisons too palpable for argument.

It can't have been easy in the slightest way for this reclusive and gentle man to continue his devotional art after Duncan's sad death. But he has. *Cher Maître!*

WALLACE STEVENS
(1879-1955)

THE FOOTSTONE OF HIS GRAVE in the old Hartford, Connecticut town cemetery, Cedar Hills, south of Trinity College. His daughter, Holly, took me to the site about 40 years ago.

Rexroth, perversely, joked that Stevens wrote just the kind of poems a prosperous insurance man would write. If that's a problem, it's never been a problem for me. He is one of my masters. He endures obdurately, and all blackbirds join me in saying so.

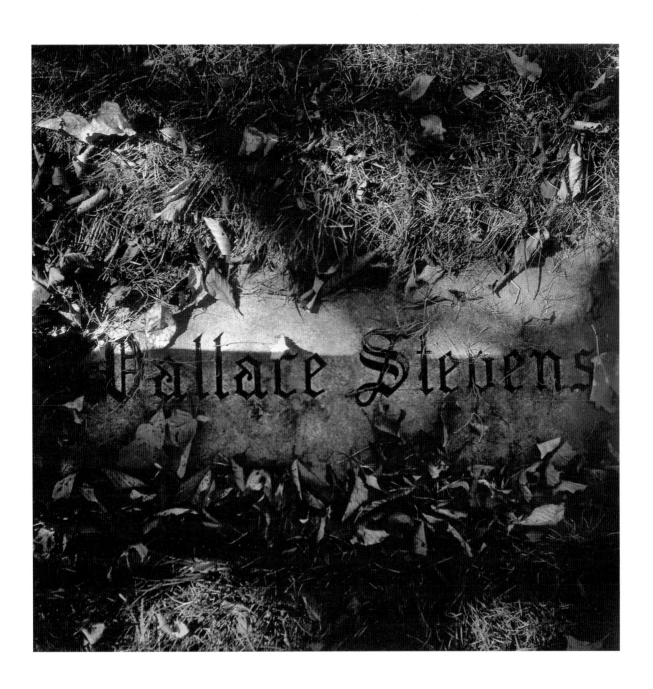

PAUL STRAND
(1890–1976)

I WENT TO HAVE DINNER with Strand in Orgeval, west of Paris, one summer evening in 1966. Minor White told me where he was. I don't remember much about the occasion except it was an honor to be there in the presence of one of the master photographers the last century produced.

He told me (since I was living in London at the time) to make it my business to visit Alvin Langdon Coburn in the Conway Valley of Wales. I did just that, a few months later. And don't have much but vague, pleasant memories of that either. It seems a long time ago. Coburn told me he first went to Wales in 1898 (the year my father was born) and kindly gave me a new gravure print of his famous print of St. Paul's Cathedral. Rather foxed, it hangs still in the bedroom here in Highlands. Alas, no Strands on the walls, but most of the books.

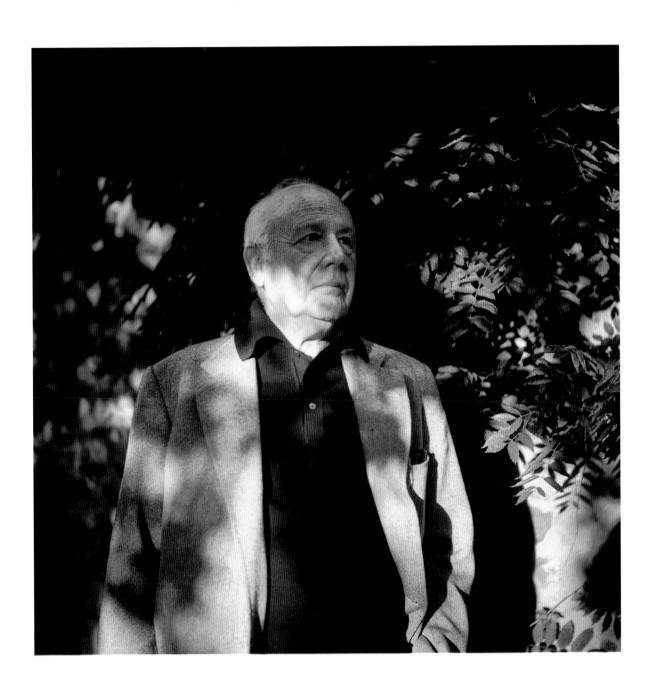

IN THE EMBATTLED GARDEN OF
IAN HAMILTON FINLAY (1925—)

THIS LITTLE POEM is cut into a footstone on a path in Finlay's garden, Stonypath, Little Sparta, Dunsyre, Lanarkshire ML11 8NG, Scotland, about an hour southwest of Edinburgh, in the Pentland Hills. In order to visit, you must phone first. From the UK: (0189981) 252. But, they mess with the numbers constantly. Better check with Directory Enquiries.

I love this poem. It may even be a translation by Finlay from the French of someone like Francis Ponge. Never mind. It's so beautiful. And it needs weeding regularly in summertime.

I love Finlay's work in general and have loved the old booger (thistles, warts, and all!) most of the time since I first wrote him in the 1950s. *He is very hard work.* But I like Easy People even less than I like Easy Listening. One of our greatest contemporaries!

IHF information and publications may be obtained from Greville Worthington, St. Paulinus, Brough Park, Richmond, North Yorkshire DL10 7PT, England (UK). Telephone: (01748) 811350.

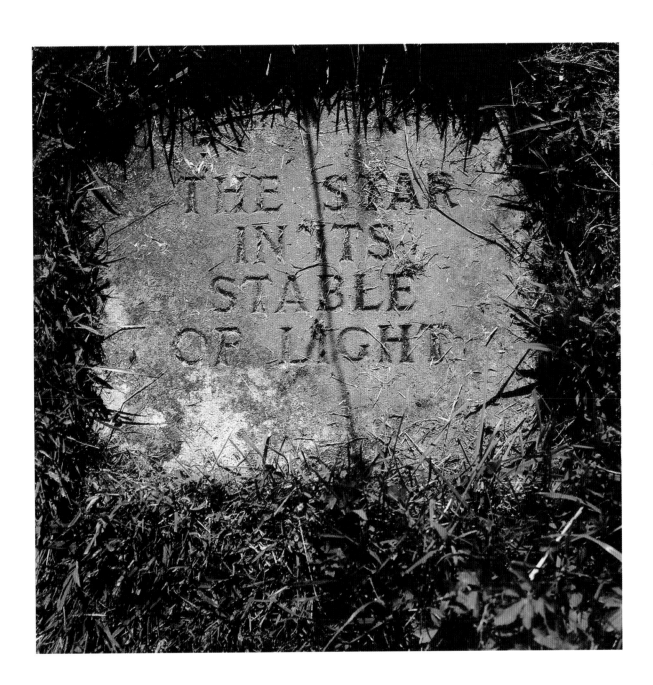

THE TOPIARY GARDEN AT LEVENS HALL, CUMBRIA

WHEN MONSIEUR GUILLAUME BEAUMONT (famous for earlier work at Hampton Court on the Thames) began at Levens Hall in 1689, there seem to have been several ancient yew trees around which he could shape a topiary garden. This one suggests *Alice in Wonderland*, or Magritte, as you wish.

It is one of the most "satisfactory" gardens in the world. We visit it four or five times a year, with always-overwhelmed guests. It's not just the incomparable topiary, but the beech hedges, the ha-ha, the herbaceous borders, the herb garden, the water garden. Location: down the A-6, about 15 minutes south of the market town of Kendal in Cumbria.

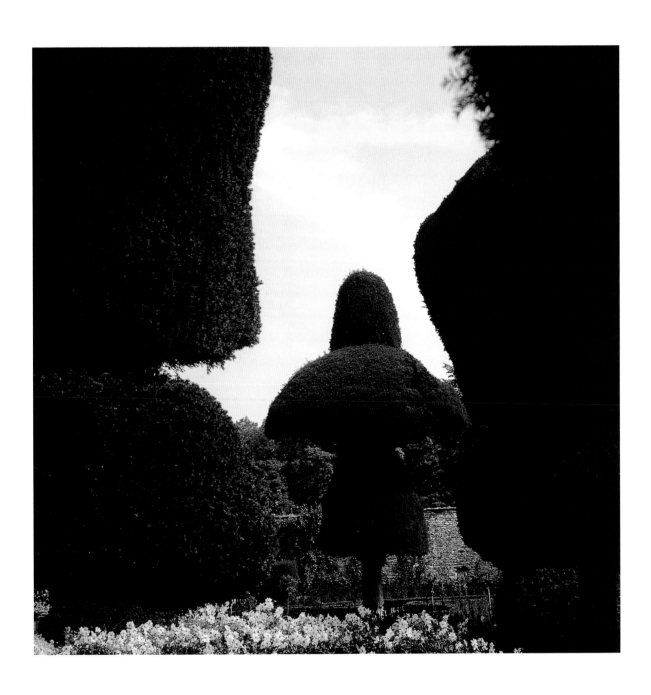

LORINE NIEDECKER
(1903–1970)

W HEN J ARGON PUBLISHED Lorine Niedecker's *T & G* in 1969, I wrote a jacket blurb which says what I felt then and, equally, what I feel now:

"Lorine Niedecker is the most absolute poetess since Emily Dickinson. She shuns the public world, lives, reads, and writes, very quietly, near the town of Fort Atkinson, Wisconsin, by the Rock River on its way to Lake Koshkonong. Her importance to — and remove from — the urbane literary establishment is of the rank of Miss Dickinson's. We are in the presence of a poet whose peers are the Lady Ono Komachi and Sappho. Few others come to mind."

Louis Zukofsky included poems of Lorine Niedecker in his teaching anthology, *A Test of Poetry*, under the folk category. He says: "The less poetry is concerned with the everyday existence and the rhythmic talents of a people the less readable that poetry is likely to be." She is in the best realist tradition and uses a plain, rustic line — the old farmland potato, that savory style so longed for by Edward Dahlberg and William Carlos Williams.

Miss Niedecker is as faithful and recurrent, as beautiful and homely, as my favorite peony bush. Every year for over thirty years she has been putting out these blossoms. Perhaps other eyes are ripe for them now?

When I went to her grave in the 1980s to pay my respects, how strange to find her buried in the family plot, where the name was spelled NEIDECKER. What story does that tell? Maybe just a dyslectic stonemason, not a blow for freedom from the family name. We still await the first biography, but much may be learned from reading *Lorine Niedecker: Woman and Poet*, edited by Jenny Penberthy, and published by the National Poetry Foundation, University of Maine, Orono, Maine, 1996.

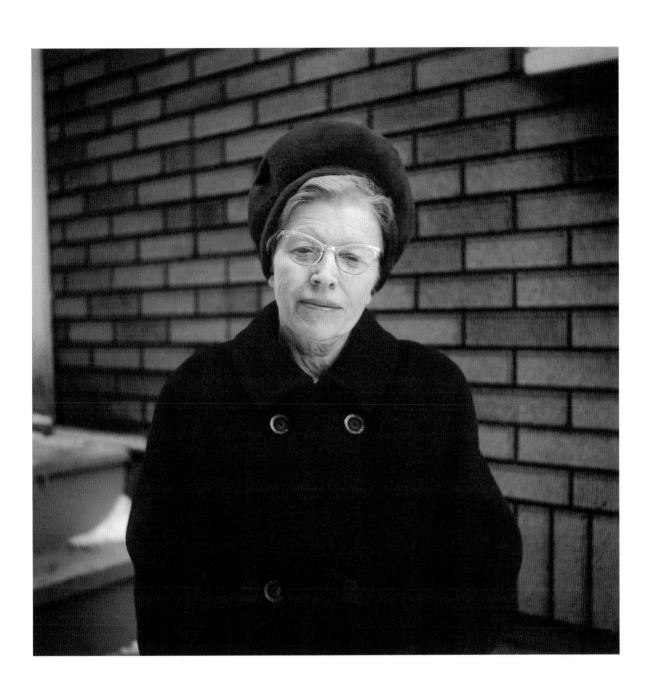

LOUIS ZUKOFSKY
(1904–1978)

THE GRAND OLD MANDARIN of Willow Street, Brooklyn Heights, about 1958. How very long ago that seems.

Robert Duncan began beating drums in my ear in 1954 about how I should publish this extraordinary poet. And Jargon did perhaps its loveliest book, *Some Time*, a book of LZ's shorter poems, in 1956. A Japanese book, printed in Stuttgart by the printshop of Dr. Walter Cantz, with uncut pages and a string binding. Just right! Colors like a plum orchard.

By the 1960s we somehow fell out of sympathy. The Zuk seemed to resent any book we published that didn't have his name on the spine. (He is hardly the first or only one to do that.) I didn't like all the kvetching and didn't behave nicely in return. I don't like to think about it. I like to think I can handle yentas better than the ornery Baptists in my heritage, particularly when they write dreck. LZ writes like an angel on so many occasions. What a country. In 1999 one person in a million has heard of Louis Zukofsky. Michael Jackson sure hasn't. Mike Tyson, born again (and again and again) hasn't. Bubba hasn't. Trent Lott hasn't. Elton hasn't. The English Department at Harvard hasn't. We live in a nation of hasn't; and of those who couldn't possibly want to know.

A most distinguished man. He could pop your clogs and wreck your head. And dumbfound you with the simplest of beauties.

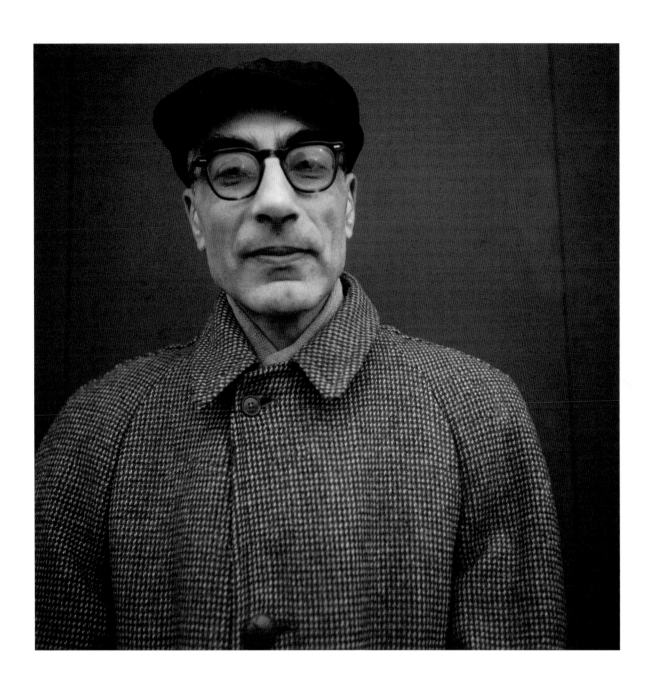

SERGEI VASILYEVICH RACHMANINOFF
(1873–1943)

WHY RACHMANINOFF IS BURIED in the Kensico Cemetery, Valhalla, New York (west of White Plains), is something I have never been able to discover. He is there with Lou Gehrig, Herbert Lehman, and Donald Meek (the Scottish character actor I always thought should have played the Wizard of Oz in the movie). *¿Quien sabe?*

I heard him play the *Fourth Piano Concerto* with Ormandy and the Philadelphia in Constitution Hall, Washington, DC, in 1942, when I was twelve years old. It made a lot of difference. He has never been a composer that etiolated squares had any time for. So what? He was passionate, virtuosic, misanthropic, way out of it — some of the things I like best. If I were to stop now and put on the old Columbia LP of Horowitz incinerating the *Second Piano Sonata*, I might just go to pieces altogether. That sonata is one of my glories. I hope Jesse Helms has never heard it. I hope Pierre Boulez has not heard it too much. You guys, just go somewhere else, ok?

Do you know what he said on his deathbed? "Farewell, farewell, my beloved hands!"

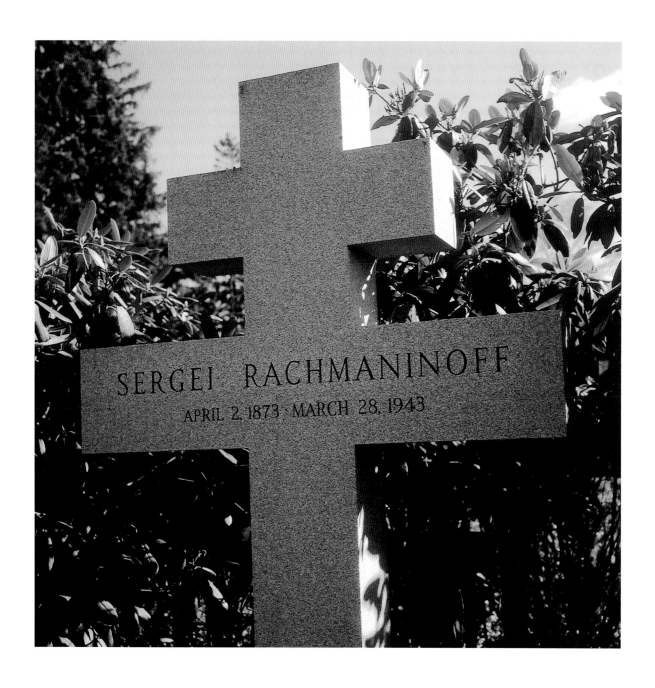

CLARENCE JOHN LAUGHLIN
(1905–1985)

THIS IS THE LAST TIME I photographed Clarence John, back of his house in the Marigny District of New Orleans. Must have been about 1980. He was diminished by his infirmities and had become hooded and shadowed.

One of the best pieces I've ever written about anybody was about Clarence, called "The Shadow of His Equipage." It was the introduction to *Clarence John Laughlin: The Personal Eye*, an Aperture monograph, 1973. It is also reprinted in mybook of essays from North Point Press, *The Magpie's Bagpipe*. It's around.

CJL's 17,000 negatives, hundreds of prints, much of his library, are contained in the archives of The Historic New Orleans Collection, 533 Royal Street in the French Quarter. The expert curator is the photographer John Lawrence, who loves to talk Clarence and knows what he's talking about. It is interesting to remember that Clarence considered himself a writer first, a book collector second, and a photographer third. His ability to find magic in obscure texts was as preternatural as his insight into the secret life of objects and dwellings.

Upon his request, Clarence John Laughlin was buried in Père-Lachaise Cemetery, Paris. I will go there someday, eat a beignet, and drink a sip of Wild Irish Rosé, that hideous wine he so perversely favored, a memory from his Cajun boyhood near New Iberia.

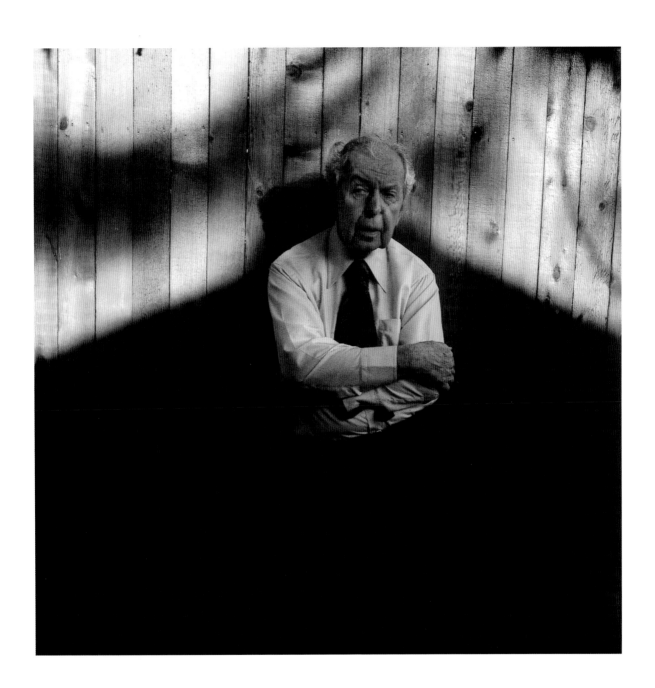

WYNN BULLOCK IN HIS GARDEN IN MONTEREY, CALIFORNIA (1902–1975)

A REMARKABLY NICE MAN, still so very vivid, able to take remarkable photographs, which he worried and worried about like a dog with a bone. *Symbol* and *spatio-temporal* and *fourth-dimension* and *radiance* were words that got bantered about at the picnics overlooking the sea. I look at the images now and see them as rock-solid, marvelously and quietly seen — what was all the talk and fuss about?

I wrote a piece for *Aperture* when Wynn died. The beginning seems apposite:

Lea is one of the things you find if you dig into the body of the word *light*, which was Wynn's meat. Wynn's mead; Wynn's meadow — now you can see how *lea* gets close to *meadow* — "and the brightness begins."

Wynn Bullock was deeply (perhaps sorely) affected by Alfred Korzybski's dictum: "the word is not the thing." Yet there are "things" in the Indo-European roots of the word *bullock* that give us some light. *Bhel-*, to blow, swell; with derivatives referring to various round objects and to the notion of tumescent masculinity. It comforts this man, who makes his world out of words, to recognize that Bullock was indeed the spatio-temporal continuum he insisted he was. Not just the Old Norse *boli*, from whence BULL and BOLLIX, but such marvelous connections with the world as the BOLE of a tree; with BOULDER; with BOWL; with BULWARK; with BOLD; even with BALEEN.

Wynn Bullock was a luminous man, with a windy, cloudy, lovely nature. I don't forget my times with him along the Big Sur Coast in the 1950s and 1960s. Very special times. It seemed that the photographers at work on those sacred places (Wild Cat Creek, Point Lobos, the Highlands, Carmel Valley, Tassajara, Garrapata Beach, Point Sur) whistled Sibelius's *Oceanides* as they made images.

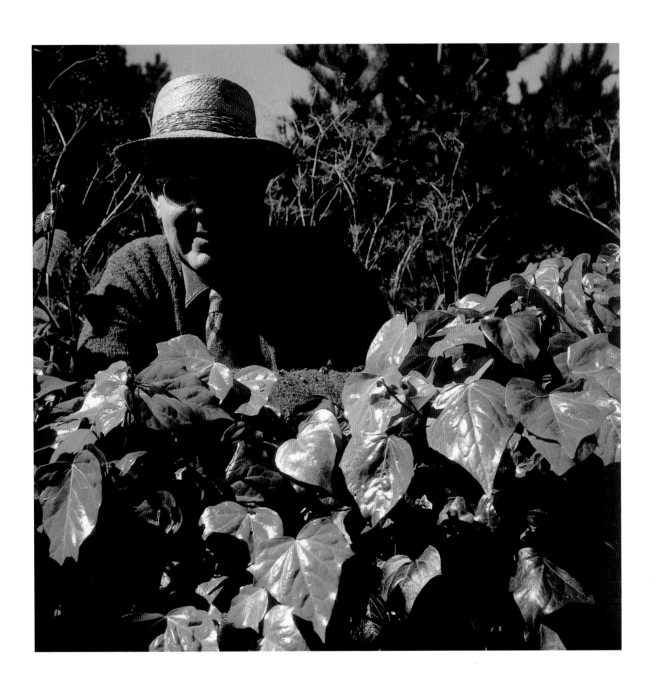

LAURA POPE FORRESTER (1873–1953) lived in a white farmhouse surrounded by cedars and pecan trees out in the country between the southwest Georgia towns of Meigs and Cairo. Pelham is also somewhere thereabouts. In Cairo, a town of 8,061 souls, they get together every spring and round up rattlesnakes, frying up a few for the culinary degustation of what intrepid tourists they can lure into Grady County.

From 1908 until her death, Mrs. Forrester built (with no formal training at all) an extraordinary sculpture garden. Fronting the highway, she contrived a wall and gateway made out of concrete and cast-iron legs of Victorian sewing machines. General Dwight D. Eisenhower and General Douglas MacArthur were two of the busts atop the wall. By the time I got to the place in the late 1970s, of the some 200 cement statues only those built into the wall remained — about 12. In 1974 the property was sold by Mrs. Forrester's only surviving son to a Mr. E. E. Nixon, a man who ran a milling company in Meigs. After the Nixon family moved in, the new owner said to Tom Patterson about the statues: "They had done passed their days of bein' useful. So we've taken down just about all of 'em."

Based on the little evidence that remains, this is one of the worst pieces of unconscious vandalism that one has ever heard of. How *could* the museums and historical societies and university art departments and collectors of the state of Georgia — or just local citizens with eyes in their heads — have allowed this destruction to take place? Laura Pope Forrester's figures (religious, patriotic, historic, literary) included Adam and Eve in the Garden of Eden, Scarlett O'Hara, Army and Red Cross nurses, Japanese war mothers, Uncas (the Indian hero of James Fenimore Cooper's *The Last of the Mohicans*), Nancy Hart (the Georgia Revolutionary War heroine who single-handedly killed six British soldiers), and a series of masque-sized plaster faces representing the world's seven major religions.

It is the skill of her work that is so uncanny. She, apparently, often used plaster casts from the faces of her friends. There is perhaps a serenity of expression that one has never seen anywhere else except on certain Buddhist and Hindu temples.

In another part of the South, a man of Laura Pope Forrester's time wrote: "Remembering speechlessly we seek the great forgotten language, the lost lane-end into heaven, a stone, a leaf, an unfound door. Where? When? O lost, and by the wind grieved, ghost, come back again."

SANDRA FISHER
(1947–1994)

It is very hard to say anything at all cogent about this lovely woman and lovely artist. Tom Meyer and I thought we would know her all our lives and, suddenly, in September, 1994, we were telephoned that she had died over the weekend in London. It was only three weeks after a visit in Cumbria with us, with her son Max and her father Gene, when she was alluringly and vitally herself. There was talk of an aneurysm, or possibly some dreadful, galloping encephalitic virus.

A serene and radiant person. On the occasion of this photograph in the early 1980s, we were walking on the Howgill Fells above Sedbergh in Cumbria with her husband, R.B. Kitaj, and with David Hockney. Her death pulled the rug out from under more people than almost anyone's I have known. Dear Max, dear Gene, dear Kitaj — what a loss! But, there is much of her distinguished work to cherish. One can only say, abjectly, that one mustn't ever forget that.

The Howgill Fells must count themselves lucky to have felt her presence.

WILLARD MIDGETTE
(1937–1978)

How could this extraordinary man have died of a brain tumor at the age of 40? Extraordinary men, I am told, do it all the time, but we, typically, don't want to pay that close attention to our scarifying, common frailties.

A very interesting painter. He didn't smoke, he didn't drink. He was intensely physical. He was brilliant and ebullient. He was nervous as a cat. I don't know what that says.

I met him in 1960 when he was a student of James McGarrell at Indiana University in Bloomington. And knew him well in Taos and in Portland, Oregon (at Reed College), when he'd married Sally Driver. I knew them both, later again, when he was in the artists' residence program at the Roswell Museum in New Mexico. I loved his young family: daughter Anne and son Dameron. Again — one does not expect to be bereft, just like that, of one's stunning contemporaries.

Bill wasn't a gay man, but he was so sympathetic to me at a time when things were really miserable in my life that it didn't matter what he declared himself to be. He was *there*. I won't go blathering on that there are probably no gay men or no straight men either. There are what we call *friends*, i.e., friends in need.

More importantly for you: his paintings are *there*. They are of an order that deserves all your respect and attention. Go to the Roswell Museum for a start. I tell you, if we can't pay attention to art of this quality, why does the poor perishing republic think it has any reason at all to go on?

JAMES MCGARRELL
(1930 —)

THERE ARE DAYS when I can't think of a more refined and accomplished artist in America than Jim.

He hasn't taught in the fashionable places. To teach in a university in Bloomington, Indiana, and in St. Louis, Missouri, makes more sense for a mid-American baseball player. To show paintings in galleries in Paris and Umbria and Rome (despite all the shows in Chicago and New York) is probably not too wise either. We are such pussies.

I have known him a very long time. First it was in New Orleans, when he was helping make recordings of local music for Bill Russell, along with Alden Ashforth and David Wyckoff. That's about 1952. Emile Barnes, Peter Bocage, Kid Thomas Valentine, Wooden Joe Nicholas, One-Eyed Babe Phillips, Lawrence Marrero, Alchide "Slow-Drag" Pavageau — precisely the right local guys.

Like Philip Guston, he has kept at it. Knowledge of Max Beckmann, knowledge of Balthus. Knowledge of the Cardinals, knowledge of the Indiana Hoosiers. Fantastic knowledge of a great tradition of European and American painting. You sense in him a depth of command as well as his great finesse. At this moment he is working quietly away in a mansarded attic in Newbury, Vermont. He has painted the four walls of the dining room and the mantelpiece into a 68-foot composition called "Redwings." The color is stunning. His wife Ann (poet and translator), daughter, Flora (media artist), and son, Andrew (librarian), are lucky to dine in such splendor.

James McGarrell reminds me of Maurice Ravel, who had to keep doing it on his own. "O Sing, O Barren."

CHARLES PARKER
(1920–1955)

In the black cemetery in East Kansas City, Missouri. The week before I went there, circa 1960, Dizzy Gillespie and his band had played KC, gone to the grave, played elegies and riffs, and left flowers at the site.

Notice the little birds on the stone (tweet tweet). Mama got it right, in her way.

BIRD LIVES! No doubt about that! We're still "Chasin' the Bird."

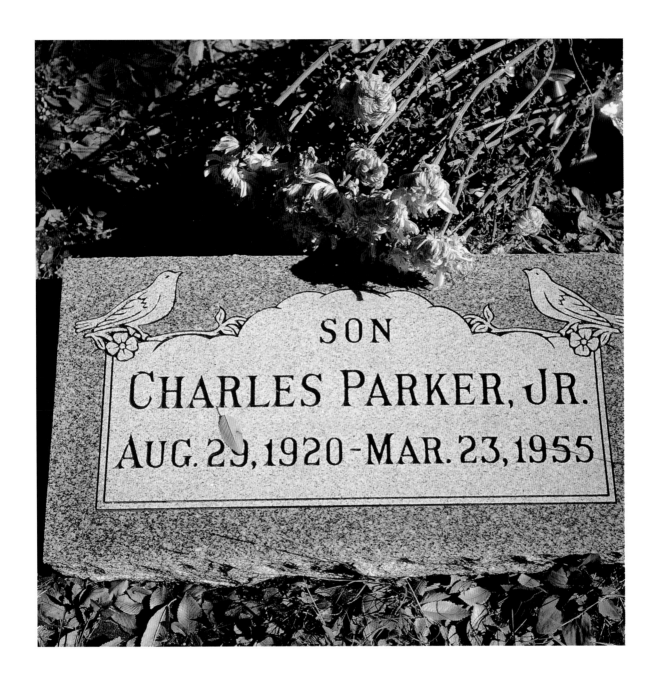

SON
CHARLES PARKER, JR.
AUG. 29, 1920 - MAR. 23, 1955

"THE SHADOWS ON THE TECHE,"
NEW IBERIA, LOUISIANA

A GREAT PLANTATION HOUSE last occupied by the last of the family line, Weeks Hall (1899–1962): painter, drinker, and protean character. I used to go there in the 1950s to dine and drink with the great man. His house was 1830 or so, of local brick, one of the unique places in the Louisiana bayous. I don't think I have ever been in a house more beautiful or that I liked more.

His devoted black menservants, Clemmy and Raymond, protected Weeks from the local blue-haired bourgeoisie and the tourists. He'd studied art with Arthur B. Carles in Philadelphia way back when. He'd subsequently devoted his life to preserving the property, lest the town turn it into a parking lot for a supermarket. Henry Miller and Abe Rattner had been his guests. Sherwood Anderson, Faulkner — and maybe Miss Stein and Miss Toklas. There is a plain wooden door where you will find amazing names written upon it. Even mine.

The elderly Bunk Johnson had worked in the garden. When he was totally drunk and Mr. Weeks was totally drunk, Bunk would drag out the old cornet and play stuff with his toothless gums. Weeks had a habit of falling off the second-story balcony into the bushes. He usually greeted you with a cast on an arm or a leg.

I remember the coffee and crystal sugar in little silver cups and the crazy talk and whiskey that went on long into the night.

Weeks had Bunk buried (with no name) in the Weeks family plot in the town cemetery. Bunk had said to him: "Please, Mr. Weeks, don't bury me amongst them field niggers. I can't stand all the cane dust and mule farts."

Now, it is National Trust property. Definitely worth a visit, but hardly the same. Blue-Hair done won!

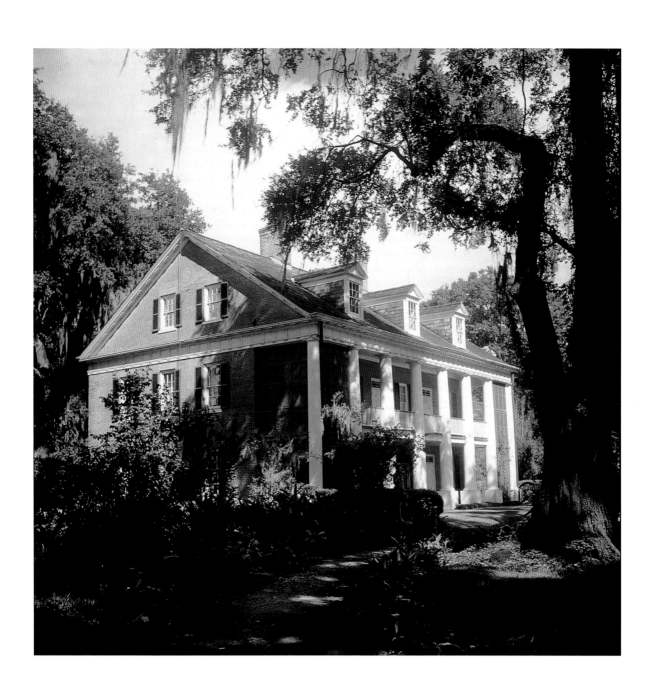

VOLLIS SIMPSON AND THE WIND MACHINES
OF LUCAMA

THE DAY I MET Vollis Simpson, I heard on TV in a motel in Rocky Mount that Wallis Simpson had died. Well, it just goes to show. It just goes to show what?

Vollis Simpson doesn't know where mama and papa got the name *Vollis*. He's had a brother named Dewey Roosevelt Simpson (not Thomas E. & Franklin D., but Admiral & Teddy). And another named Groves, and one named Daryl, pronounced *Darl*. Obviously, a family of inventors.

One connects *Vollis*, this man born into tenant farming (corn, cotton, tobacco) in Lucama, North Carolina, with *volant* and *volatile*. A-I-R! What he loves is airplanes and the wind moving machines through space. At Moore's Crossroads, he has built a lake, grassed in an old mule pasture, and started building a "mess," a unique cluster of over 40 giant whirligigs and complex totems out of scrap metal. "First thing I ever built was a wind-powered washing machine on Saipan in the Marianas. We were living rough, in fox-holes, and did a lot of crawlin' to stay alive, just like moles. My job was helping make landing strips out of that green coral rock. The B-52s took off from there to bomb Japan."

Vollis survived the wars in the Pacific. Back in Lucama, farming was wearing out. He started a repair shop and learned to build anything mechanical needed in the county — tractors for tobacco were still in demand. In 1985, aged 66, he began the towers. He jokes: "There was so much junk in the shop, we either had to close down or think of something new." There are no models for what Vollis Simpson is doing. This is mobile sculpture on a vast scale, made with astonishing craft and ingenuity. Figures with a touch of Miró and Dubuffet play guitars; wagons and horses move; a pole with a huge colored metal parasol on top; two men use a long saw on a big log; propellers of planes turn in great circles; giant dogs wag tails against the sky. Give Mr. Simpson five more years, he may have more visitors than Sam's Towers, Canyon de Chelly, and the Wright Brothers National Monument put together. Advance reservations suggested at the Lucama Hilton.

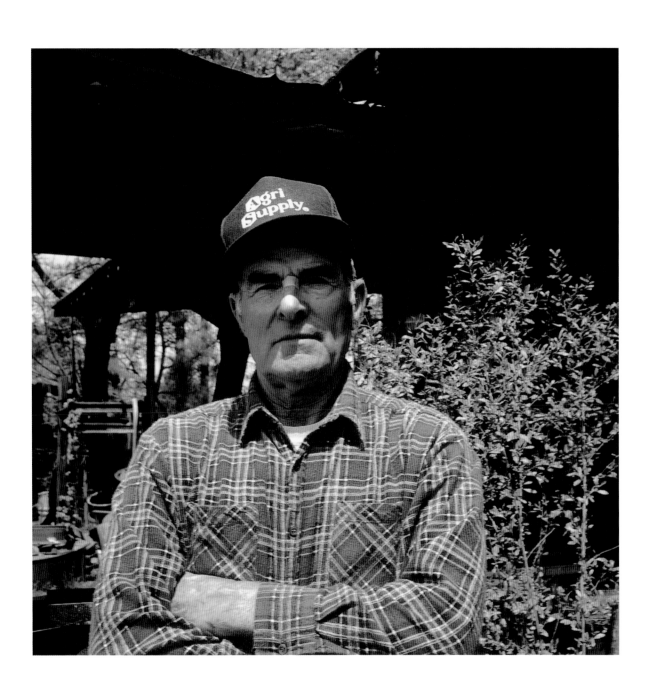

How to find it? Go to Wilson, North Carolina, about an hour east of the capital, Raleigh. You might want to stop for barbecue at one of the state's oldest establishments, Parker's. It's on U.S. 301 South, a truck route on the west side of town. (Vollis says he prefers the food at Bill's Place, so if you happen to spot that too, see what they can do with a fat sammich.) Go on from Parker's on 301 South and look for Madame Bogart's palm-reading headquarters on the right. Go about three-tenths of a mile, cross a bridge, turn right. The sign says Lamm's Crossing. It's about six miles to Lamm's Crossing. When you get there, keep straight ahead. In the pine trees, you will begin to see the machines moving.

Another place to see a Vollis Simpson is at the American Visionary Art Museum in Baltimore. I haven't been to Baltimore since AVAM and Camden Yards were opened. I need to go.

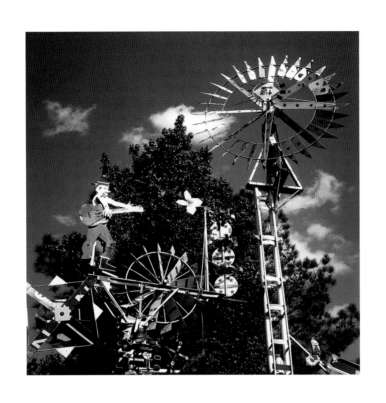

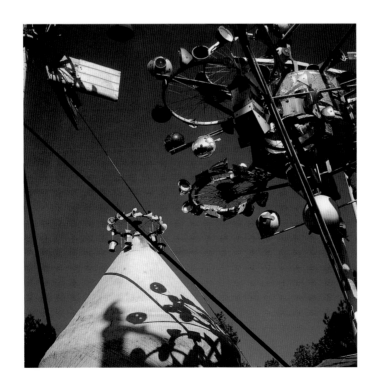

FREDERICK SOMMER
(1905–1999)

I WENT OUT TO THE J. Paul Getty Museum in January, 1995 to give an hour's talk to honor Fred Sommer's 90th birthday. Monsoon conditions were battering Malibu, but 250 Sommerians packed the auditorium, given the chance also to see the exhibition, *Poetry and Logic*, showing 38 photographs by this precise and scorifying master. Sommer is also a master aphorist. Sage Heraclitus would love to have said: "Some speak of a return to nature — I wonder where they could have been?"

The last two paragraphs of my talk will indicate my regard for him as a man and my respect for his achievement as a photographic and calligraphic artist.

"I see Frederick Sommer as one modern avatar of ancient Orpheus. In Robert Graves's *The Greek Myths*, Orpheus is described as the son of the Thracian king, Oeagrus, and the muse, Calliope — 'the most famous poet and musician who ever lived. Apollo presented him with a lyre, and the Muses taught him its use, so that he not only enchanted wild beasts, but made the trees and rocks move from their places to follow the sound of his music. At Zone, in Thrace, a number of ancient mountain oaks are still standing in the pattern of one of his dances, just as he left them.'"

I give the Old Fireballer the last word, because it shares affinities with what I have just read:

"I have five pebbles, not too different in size and weight, yet a randomness about them. If I drop them on the carpet they will scatter. Now we could run an experiment and we would find that we cannot put these pebbles in shapes that would be as elegant and as nicely related and with as great a variety as every time they fall. It is better than anything we could do. I have great respect for the way I find things. Every time something falls I look. I cannot believe the relationships. The intricacy. You hear a noise and you say 'What is that?' Respect for the affirmation of the unexpected."

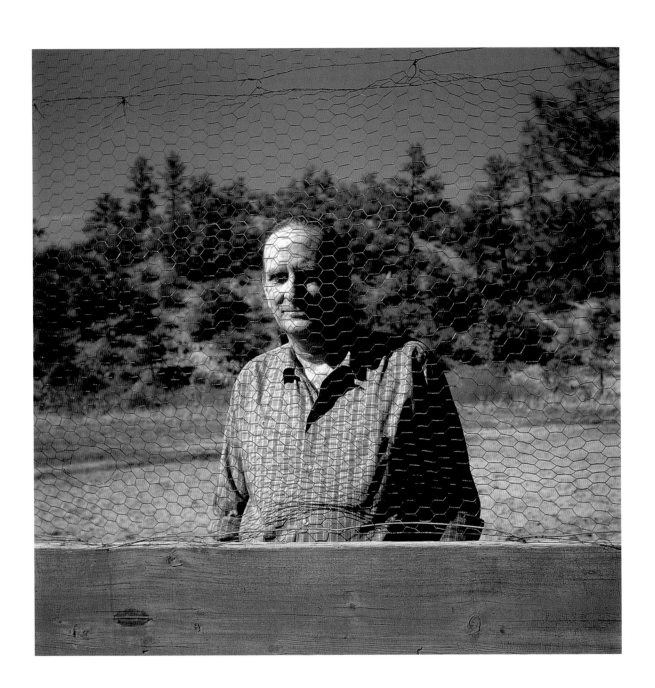

GOD IS LOVE

THIS PANEL was on the side of a black church on the highway east of Wilson, North Carolina, real tobacco country. Roger Manley (folklorist, anthropologist, curator of Outsider Art, photographer, and internationally known devourer of pig meat) took me there one afternoon after some barbecue at Parker's venerable establishment.

On a subsequent trip Roger found the church abandoned and derelict. Someone had thrown this wonderful panel into the weeds. Roger saved it and now it's in his personal collection in Durham, NC.

I might add that when I brood darkly that only dirtbags like Senator Jesse Helms seem to come out of North Carolina nowadays, then I remember that Roger Manley also comes from the Tarheel State, and there is no one more humane and useful alive on the planet. To be his friend is an honor.

THE INDOMITABLE GEORGIA BLIZZARD
OF GLADE SPRING

ANYBODY WITH HALF AN EAR and the top half of an imagination already knows that a person named Georgia Blizzard has to be somebody very special. Also note the names she gives to some of her clay vessels: "The Wish Pot," "The Preyers," "Rattler on the Ledge," "A Frolic in the Grouch's Meadow Could Make the Grump a Better Fellow," and "Sweet Is the Bleating of the Ewe and Lamb in the Meadow."

Georgia is part Apache, part Irish, and part William Blake. (I still don't know how her grandfather, the Apache Indian, happened to make it from Arizona all the way to Smyth County, Virginia.) She was born May 17, 1919 in Saltville, in Poor Valley, but her family moved to Plum Creek when she was a young child. She and her sister, May, played along the creek and were fascinated by the "little chimneys" that the crawdads built with clay from the stream bottom. They made their own dolls and dishes and animals and other toys. They were too poor to have store-bought things. Later she learned to dig clay out of the banks and from the interior of a nearby limestone cave.

Her mother taught her to burn the clay to make it hard, as the Indians had done. Later on, she fired the pieces in a coal kiln built for her in the 1970s by her writer friend, Mike Martin. Later still, she took advantage of an electric kiln (a gift from Emory and Henry College) and now uses both. All sorts of glazing material is used: wood, dried dung, rubber scraps, coal.

Georgia said: "I had the feel of the clay. When I think back to my childhood, I can get back to myself. It seems like you can create anything if you still have that childhood magic with you. You carry it down the milestones. And you think of all that's separated you from the joy of childhood, and it seems like something evil that's separated you from it. And yet it's not. You had to leave it."

Georgia said: "I can get rid of taunting, unknowing things by bringing them out where I can see them . . . I feel the need to do it . . . It's all I have left."

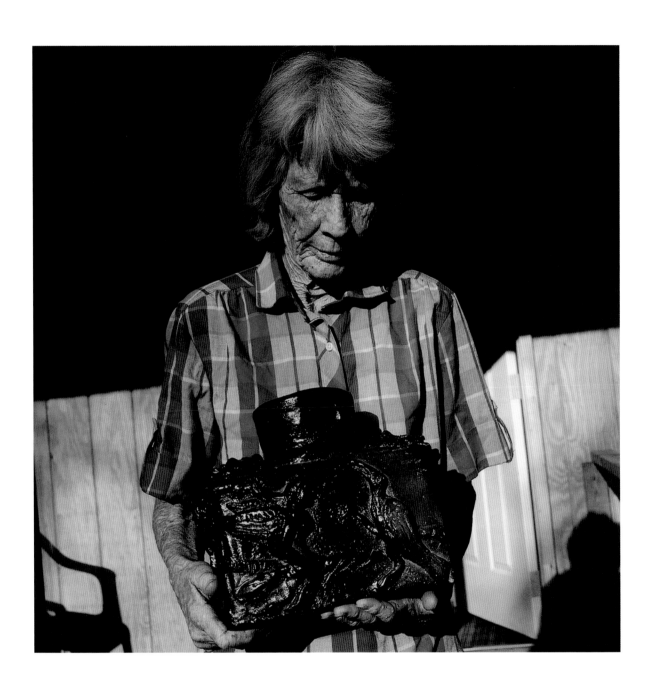

AARON SISKIND
(1908–1991)

ALL MY FAVORITE avuncular adjectives trot forth when I think about Aaron Siskind: *kindly, astute, enthusiastic, loyal, uproarious, masterly*. Has there ever been a greater photographer? To ask that excessive question is not to diminish the tremendous range of Paul Strand or the depth of feeling in Stieglitz or Sudek. I merely suggest that Siskind could mount 400 prints on the wall and not show us one second-rate image. The same might be said for Pierre Bonnard and Richard Diebenkorn, both painters — I can't think of any others.

Siskind and his Abstract Expressionist painter pals in New York (de Kooning, Kline, Tworkov, Kerkham, Vicente, Gorky) were among the first to show us that our innermost feelings can be found in the commonplace debris of the world, that they can be limned on walls and in stones and bits of ironwork. I remember a famous Siskind statement: "When you photograph a wall, you photograph a wall; when I photograph a wall, I'm photographing something else." Namely: Aaron Siskind. He wrote to me very recently: "I still love travelling. When I visit a new country, I find old Siskind there."

Siskind was nearly the last of my mentors. And now I find myself old enough to mentor to the occasional disaffected youth who wants to know about the Harry Callahans and Frederick Sommers and Art Sinsabaughs and Ralph Eugene Meatyards of this flensed world. Franz Kline and Aaron Siskind talked a lot about "dancing" in an image, and of delight. "Is not the aesthetic optimum: *order, with the tensions continuing?*" asked Siskind, with precisely the warm linguistic savvy you'd expect.

Those of us who knew him miss the man enormously. Every time I see the little yellow-green finch known as the Pine Siskin, I am reminded of his somewhat (but not much) bigger Polish Uncle, Aaron. Checking *siskin*, it derives from the Swedish *siska*, a "chirper." Others who miss him are the tender Shulamite damsels of Pawtucket, Rhode Island. No one appreciated them more. "Whudda you think keeps me luggin' these heavy goddamn cameras around?" asked Aaron at lunch one day, tickling one of his retinue in the most cordial way possible.

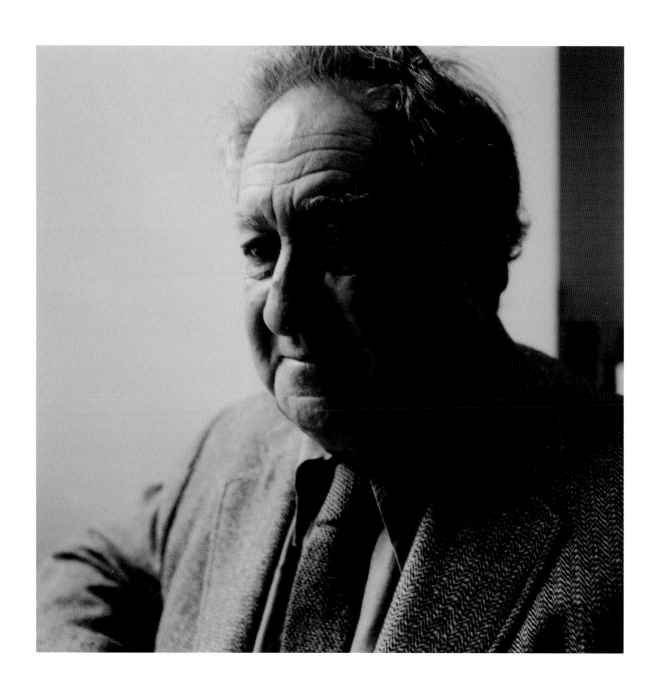

WILLEM VINCENT VAN GOGH
(1853–1890)

THE GRAVES OF VAN GOGH and his brother, Theo, in Auvers-sur-Oise, to the north-west of Paris. Beyond the cemetery wall, the wheat fields where he shot himself one July 29th.

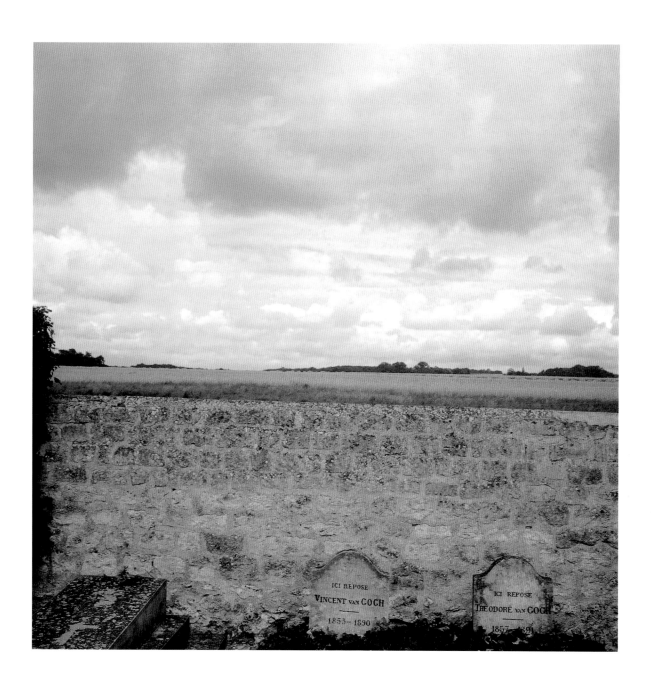

WILLIAM CARLOS WILLIAMS
(1883-1963)

WCW IN THE BACKYARD GARDEN at 9 Ridge Road, Rutherford, New Jersey. It would have been the autumn of 1961, some 16 months before his death.

New Directions Publishing Corporation will, I hope, not mind me quoting one little WCW poem, so we may savor his ease of touch, his relaxed particularity:

This Is Just to Say

I have eaten
the plums
that were in
the icebox

and which
you were probably
saving
for breakfast

Forgive me
they were delicious
so sweet
and so cold

I never forget the kindness he expressed towards my beginning efforts as a poet and as a publisher of poets: "It's a strange thing about the 'new,' in which category I place what you do. At first it shocks, even repels, such a man as myself, but in a few days, or a month, or a year, we rush to it drooling at the mouth, as if it were a fruit, an apple in winter . . . "

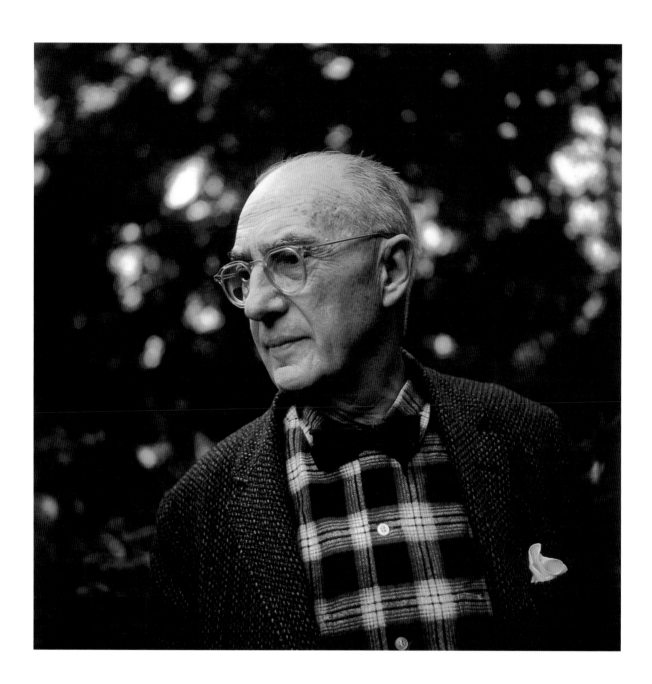

EZRA LOOMIS POUND
(1885–1972)

I ENCOUNTERED BR'ER RABBIT (as Eliot called him) only twice. The first time (1956) was at St. Elizabeth's Hospital, over the Potomac from Washington in Anacostia, Maryland. Robert Creeley and I were driving from New York to Black Mountain College. We had visited Louis Zukofsky in Brooklyn Heights and LZ had inscribed a copy of Jargon's edition of *Some Time* for Pound. We would deliver it in person, en route. Pound was sitting out on the lawn, surrounded by the likes of Eustace Mullins, John Kasper, and the retinue from Catholic University. Dorothy Pound came over and asked us who we were. We explained. Pound told her he didn't want to see people who were friends of Charles Olson. Off we slunk.

The photograph is the second occasion, in Venice, 1966. He is standing near the rooms where he wrote *A Lume Spento* 60 years before — "my window/ looked out on the Squero where Ogni Santi / meets San Trovaso . . ." These were the days of his great silence. (Guy Davenport reports dining with him one evening and all Ez said was "gnocchi.") Nothing was said of great moment that afternoon, except his parting aside: "All I did was make a little noise for some guys that nobody was listening to."

Bill Williams said a good thing: "It's easy to forget, in our dislike for some of the parts Ezra plays, and for which there is no excuse, that virtue can still be a mark of greatness."

One of my better clerihews is for EP:

Tuber Mirum

Ezra Loomis Pound
bought a lb

of Idaho potatoes
(the Hailey Comet always ate those).

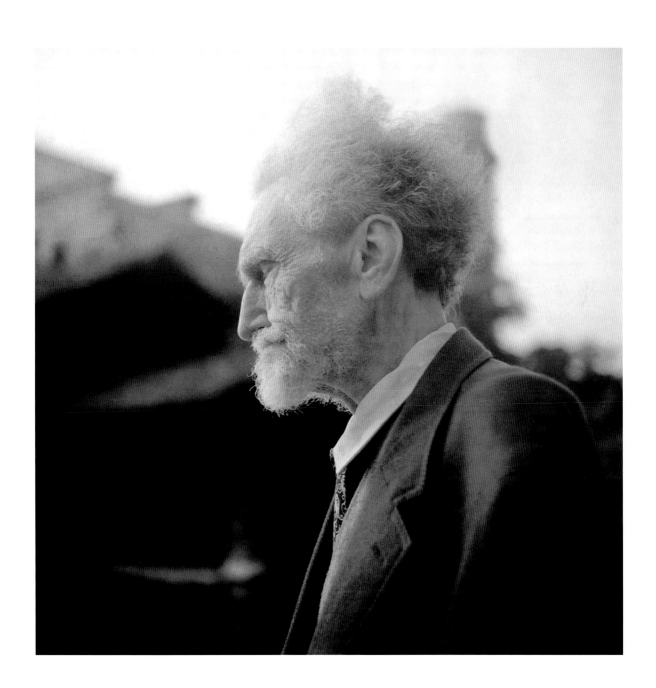

BASIL BUNTING
(1900-1985)

And a BB clerihew:

The More-Descant-And-The-Less-Real-Cant-The-Better Blues

Basil Bunting
had them grunting

darkish r's and slutchy vowels
from Rawthey Valley madrigals.

My last color photograph of The Baz, October, 1984, under the yew tree in the garden at Brigflatts Meeting House, near Sedbergh, Cumbria. Which would mean he had been coming to services at this Quaker place of quiet worship for 72 years. *Briggflatts* he calls his most intricate, expansive, autobiographical poem, though the locals seem to prefer "Brigflatts" as the spelling. It is the first meeting house in the north of England, 1675, and quite beautiful with its local stone, white plaster walls, and dark oak panelling.

An interviewer asked BB if he considered himself a Quaker poet. Bunting answered yes. "If you sit in silence, if you empty your head of all the things you usually waste your brain thinking about, there is some faint hope that something, no doubt out of the unconscious or where you will, will appear — just as George Fox would have called it, the Voice of God; and that will bring you, if not nearer God, at any rate nearer your own built-in certainties."

One of The Baz's two extant limericks is about me:

That volatile poet called Jonathan
He never gets here till he's gone again.
He holds one night stands
In a great many lands
But folks think he's just making fun o'them.

Basil is one of those people who do not fade away and leave you. He remains much more alive than 90% of the poor buggers I see schlepping through their moribund days. So, it is impossible to grasp that it's now fifteen years since we all sat around the fireplace in the parlor at Corn Close,

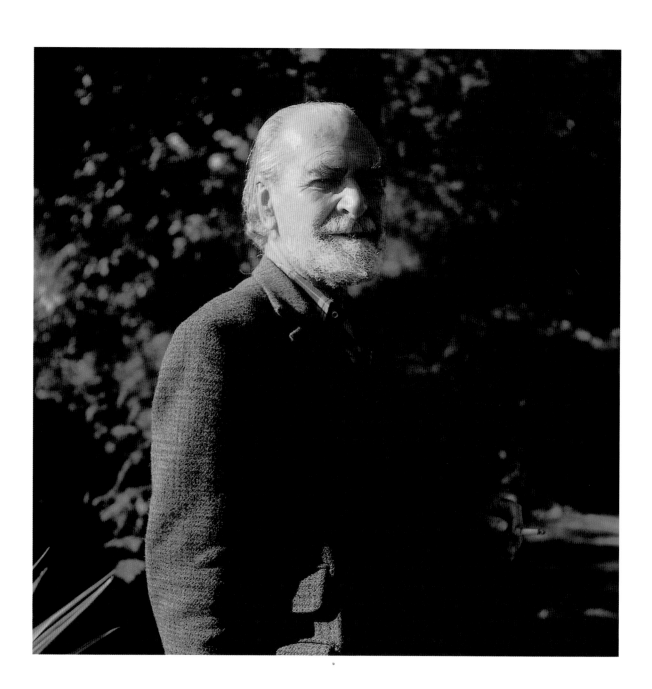

sipping Glenfiddich, arguing about who could play Chopin, discussing Rumi, Wordsworth, Pound, Zukofsky, curry, how to make a proper Singing Hinny in the Northumbrian manner, chess, cricket — all manner of stuff. And sipping Glenfiddich . . .

One day I walked from Corn Close down Dentdale along the River Dee. I crossed it at Abbot Holme Bridge and went across what they call the Elysian Fields to the footbridge over the Rawthey. From there over the fields to Brigflatts to see BB's new gravestone in the Burial Ground. Later, I wrote a few words:

Dear Basil,

Eighteen months after you left us,
poetry (that abused & discredited substance;
that refuge of untalented snobs, yobs, and bores)
sinks nearer the bottom of the whirling world.

For the rest, you there in the earth
hear the crunch of small bones
as owl and mouse, priest and weasel,
stone and cardoon, oceans and gentlemen
get on with it . . .

THE MAUSOLEUM OF WALT WHITMAN
(1819–1892)

WHITMAN ORDERED HIS TOMB, "a plain massive stone temple" of unpolished Quincy granite, for erection in Harleigh Cemetery in the town of Camden, New Jersey. His design was based on one of William Blake's symbolic etchings, "Death's Door." (Someone has told me that the triangle over the lintel was "cabalistic," but I have never been able to find out more.)

The Good Gay/Gray Poet was obsessed with his memorial, had saved royalty money for years, and contracted with a firm of monumental masons in Philadelphia to the tune of $4,000 — more than twice what his house and property on Mickel Street in Camden had cost. He declared it "the rudest most undress'd structure . . . since Egypt, perhaps since the cave dwellers."

Justin Kaplan, in his excellent *Walt Whitman: A Life*, calls this burial gesture a "pharaonic arrangement." The only thing I've ever seen rivalling it for pure chutzpa is the monument Colonel Harland Sanders ("O Praise Him, Ye of Little Finger-Lickin' Faith!") designed for himself in the old cemetery in Louisville, Kentucky. A colonnade of marble; miles of gold leaf, and absolutely hideous bronze busts of the Colonel and his Lady on two tacky plinths.

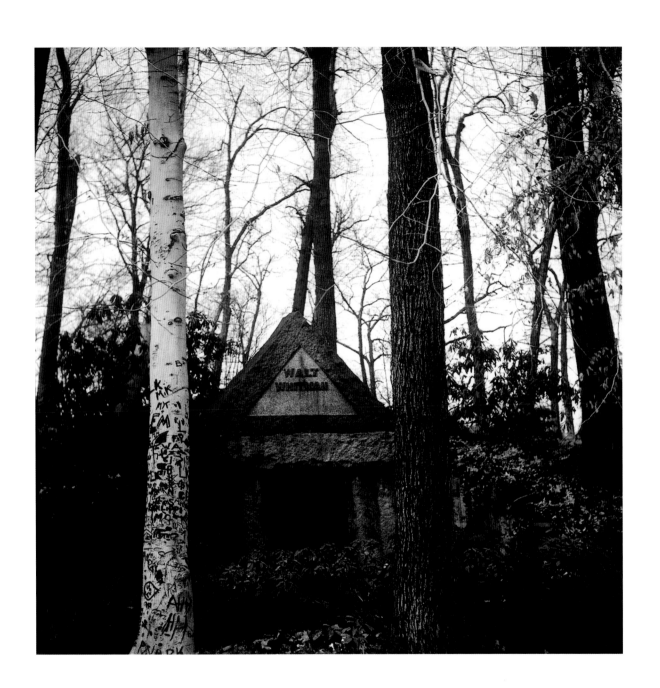

EDGAR TOLSON "THE WOODCARVER"
(1904–1984)

A MAN WHO COULD sin up a storm, who could whittle the hell out of thatthere devil wood. He was an absolute wreck. (Legend has it that he had inadvertently burned down two of his houses and blown up one of his churches when well oiled.) He'd been a farmer, a carpenter, a stonemason, a chairmaker, a cobbler, an electrician, a barn builder, a coal miner, a preacher — everybody in a desolated place like Campton, Kentucky has to do everything.

He eventually took to carving poplar wood with his pocketknife, to amuse his family and friends, to help expiate all those fundamentalist sins that swarmed through his head when the liquor got to him. His obsessive theme was the "Fall of Man." And he was an artist as distinctive in his way as Brancusi, or Arp, or Giacometti, or John Flannagan. Tolson once told Guy Mendes: "I like to sober up in the woods, livin' like the injuns, drinkin' Nehi sody pop and eatin' baloney sandwiches."

One day Edgar said he needed to rest in his armchair, so we walked over to the housetrailer. Hulda Mae was hanging out some wash. Edgar settled into his chair, shut his eyes, and moaned: "Boys, I never thought I'd hear me say there was such a thing as bad whiskey, but that whiskey I bought yesterday, that was *bad!*" The paterfamilias dozed, and just then the youngest of his brood of 18, a toddler about two, came in from the yard and bumped hard into the side of daddy's chair. The great artist opened his eyes and spoke: "Somebody ought to shoot that son-of-a-bitch!"

The last time I saw Edgar was in the summer of 1984 in the Nim Henson Nursing Home in Jackson, Breathitt County, Kentucky. He was pitiful, nothing but skin and bones. Quietly he said: "We didn't have nuthin' goin', but it still went . . . Yeah, I ain't got nuthin' — but a bad name. And I wouldn't have that, 'ceptin' people gave it to me."

In 1989 Larry Hackley took Guy Mendes and me back to Campton to see Tolson's grave. Larry, and Michael Hall and Ken Fadelay, had paid for a proper burial marker for Edgar. A granite headstone, topped with a bronze cast of Tolson's self-portrait in wood. It's a hell of a place to find. You follow Hiram's Creek up above the town. It's full of big boulders and the wrecks of cars and abandoned trucks. Then you have to get up a logging road with deep ruts, mud, and 40-degree grades. Then wander through devastated, chewed-up woodland for a mile. Then park and find an old road to where the Tolson family homestead used to be. Finally, at the end of all this ruinous landscape is a little knoll, with a circle of hardwoods and pines, and a patch of grass and wildflowers. It is a moving and marvellous place. And, there, is the stone and the little figure of the carver.

Excuse me, Walt Whitman, this is precisely where you can hear America singing. Catch the bus! Ride the dog!

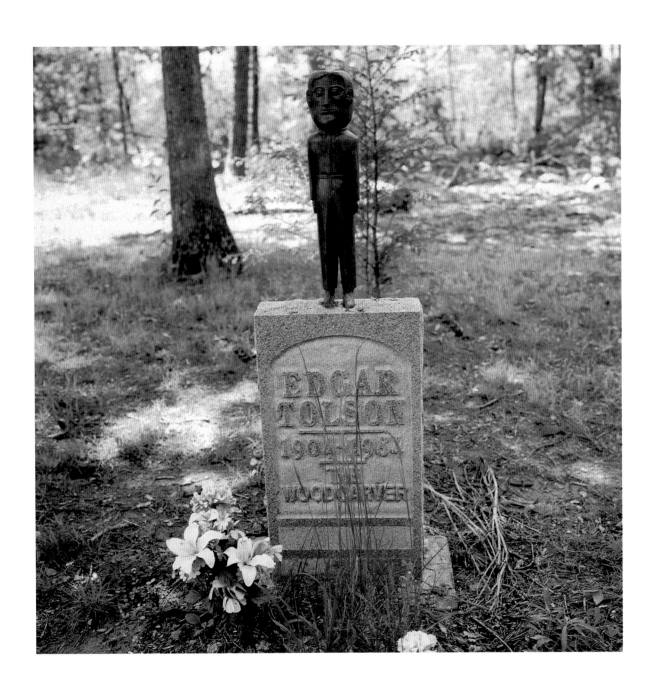

CARL MCKENZIE — CARVING A FEW PINE LINES UP SNAKY HOLLER, NADA, KENTUCKY
(1905-1998)

how old are you
Carl

i'm 50 years old
not counting
the 34 years
i went barefoot

have you been
carving much

not much boys
i'm about carved out
been whittlin' on
this bird for a week
and just makin'
shavins

i was at the cemetery just yesterday
and it just about tore me up
seein' edna's name on that stone

of course
if i heared of a widow woman
with a lotta money
and a bad cough
i might just do it one more time
even with all thesehere
miles on me

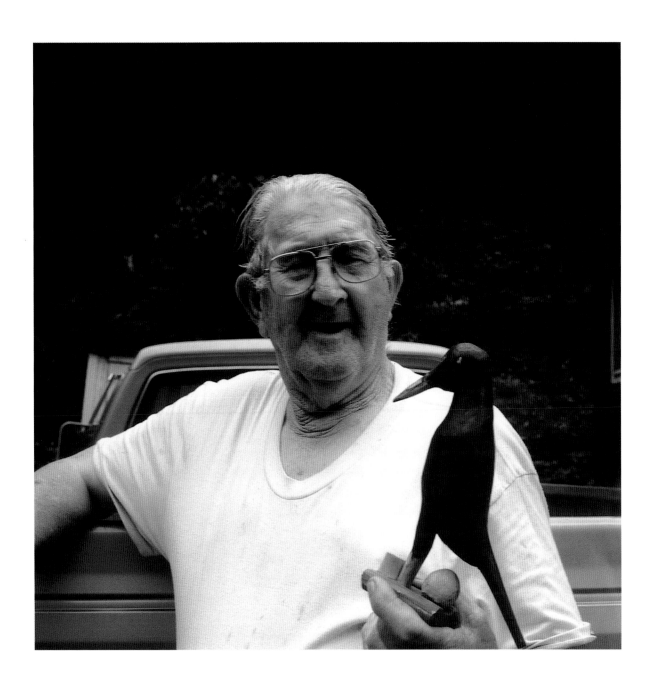

THE SAGE OF PORT ROYAL

My old friend, Wendell Berry, lives in a little place on the Kentucky River named Port Royal, Kentucky. He's a writer and a farmer. People who like writers have trouble with this. People who like farmers have trouble with this.

May I suggest a modicum of charity? From what I know, he manages to do both occupations quietly and quite well, and manages to stay out of *People* magazine.

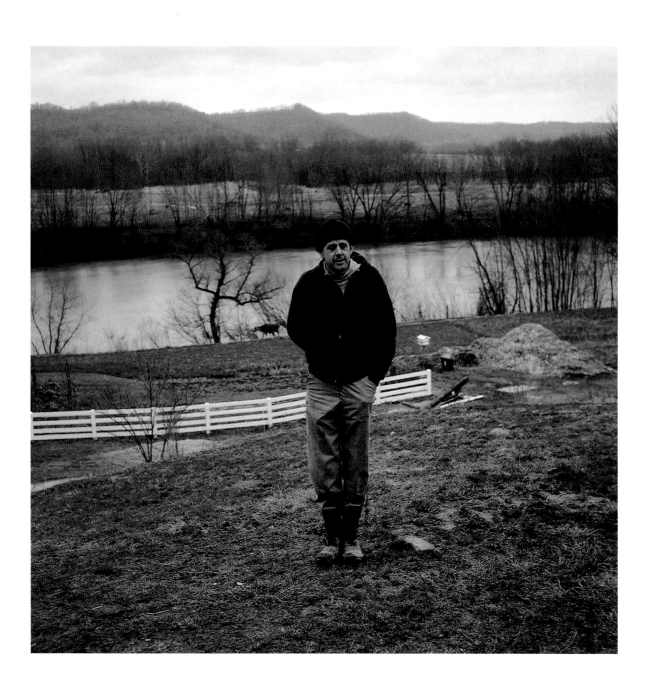

EDWARD DAHLBERG
(1900–1977)

I SELDOM BOTHER to mention the name of Edward Dahlberg these days—he is mired in the Land of Literary Obfuscation, as little to be remembered as Alpha Brazle. Yet I manage to remember Alpha Brazle! He started for the St. Louis Cardinals against Rex Barney and the Brooklyn Dodgers one afternoon in Ebbets Field. The time was autumn, 1949. I was there, with the painter Judith Rothschild, poet Weldon Kees, and the novelist Anton Myrer. (Hilton Kramer is the last man in America who writes of these people.) Anyway, Brazle had an eight-run lead in the 7th and managed to blow it. Not exactly Alpha. It was the Cardinals' gold-glove 3rd baseman, Tommy Glaviano, who let three consecutive hits go through his legs. Then Jackie Robinson and Gil Hodges started crushing everything in sight: 9–8, zip up your fly, game's over. You missed a good one, Edward Dahlberg.

Thirty or so years ago I edited *Edward Dahlberg: A Tribute*, a Festschrift for his 70th birthday. Paul Carroll said: "Is there any author living who is even in the same country as Edward Dahlberg in the moral grandeur and violence of his writings? He is the Job of American Letters." Norman Holmes Pearson said: "Edward Dahlberg is undoubtably the finest writer of our time, and certainly the wisest Man of Letters in America . . . Dahlberg will be read and quoted for generations by those who love wisdom, words, and poesy."

What wonderful titles: *Do These Bones Live, The Flea of Sodom, Because I Was Flesh, The Sorrows of Priapus, Cipango's Hinder Door, The Leafless American.*

Both Edward Dahlberg and Kenneth Rexroth are buried in the cemetery in Montecito, California. Each spent miserable last years there. Dahlberg, they say, would shout imprecations and hurl invective at certain large trees in his neighborhood, thinking them, one suspects, to be members of the Literary Merchants' Sodality.

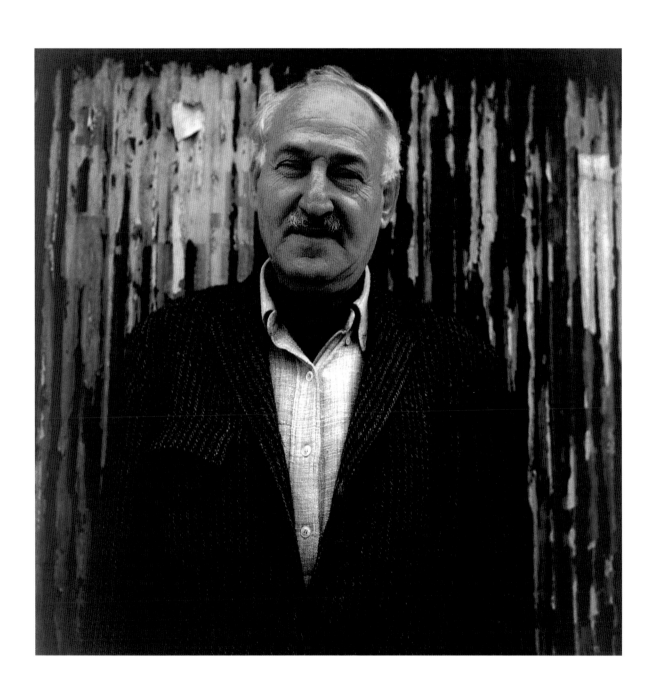

THE OLD STATE HOUSE,
BATON ROUGE, LOUISIANA

C LARENCE J OHN L AUGHLIN, naturally, alerted me to this extraordinary building. I went and was amazed. I have no further information. I can't give you verse, chapter, or line. But, as the *Michelin Guide* says: "It merits a diversion." Most people in Louisiana would rather see Jimmy Swaggart, or his satanic cousin, Jerry Lee Lewis. Just keep your head down and explain to them that "Architecture is Frozen Music."

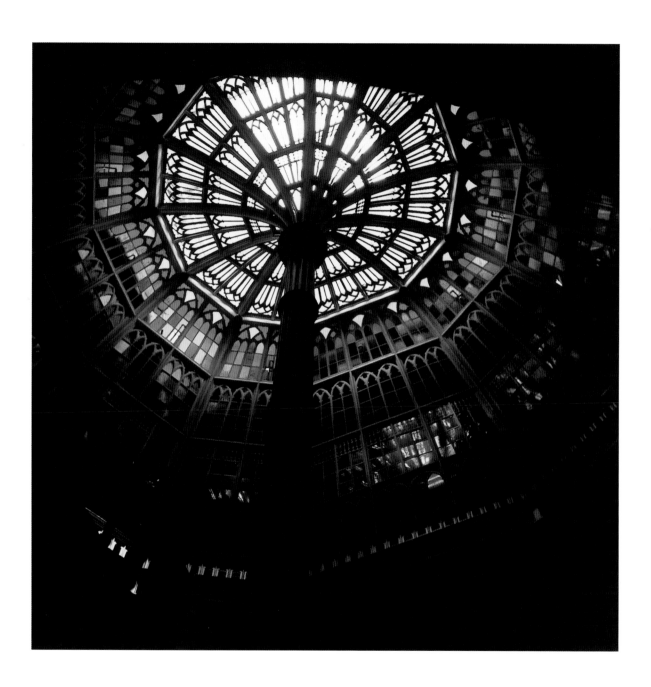

THE YOUNG MICHAEL MCCLURE
(1932—)

THIS IS MIKE McCLURE in 1954, a year or two before we published his first book, *Passages*. He was, as they say nowadays, to die for. That Black Irish Look. Allen Ginsberg just about jumped out of a window, he was that smitten. I used to call him "Allure" McClure. Neither Allen nor I ever got anywhere, anywhere at all. I once sequestered (i.e., stole) his undershorts in a cabin in Carmel Highlands and kept them as a sacred erotic object. (Did you ever do anything that crazy? I'm sure you have done much worse. I remain so demure it's pathetic.)

I have hardly had a word from him since the 1960s. We could be living on different planets. It's too bad. His poems were gloriously alive and they were "hammered," to use a baseball word. Listen, pal, so Max Reger looked like a toad. I still have to listen, when the music's that good. It's easier when you look like Mike.

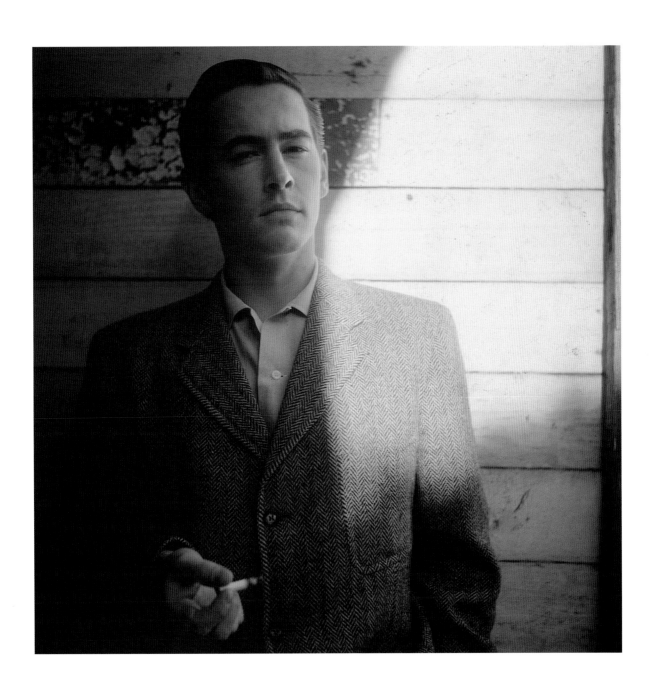

CHARLES HENRI FORD
(1913—)

A POET I HAVE BEEN READING for over 50 years. This is Charles in Central Park, New York City, in the spring of 1995. He must be nearly 82.

One of the few surrealists from Midnight, Mississippi. (Well, Brookhaven, Mississippi, if you insist.) Luckily, I am interested both in surrealists and in Mississippi small towns with funny names. Hot Coffee, Mississippi, is my favorite, but Notapater, Bobo, Soso, Homochitto, Money, and Arm are not to be ignored.

Charles Henri has a comfortable little apartment under the roof of the Dakota Apartments on the Upper West Side in Manhattan. We stop in now and again for tea with him and his devoted friend from Katmandu, Indra Tamang. The talk turns from Gertie Stein and Pavel Tchelitchew to the latest gorilla-hash about the artistes on Long Island. His accent is still mud-deep Mississippi and he is a real delight.

How little he knows or worries about our Extremely Dark Continent. Has he ever even been to Newark? I hope not. People in Newark think Tchelitchew is a new expensive drug, not yet available on the street.

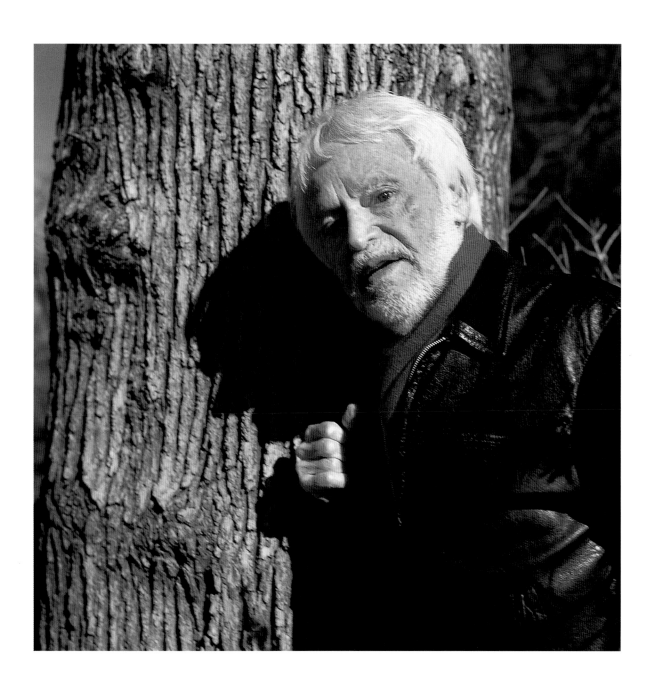

THE GARDEN OF THE MONSTERS,
BOMARZO (VITERBO)

IT'S ABOUT 33 YEARS since I located this Late-Renaissance garden, east of Viterbo and the Villa Lante, a bit south of Orvieto. With no notes and texts at hand, what else to tell you? The Duke of Bomarzo (hunchbacked and perverse, etc., as it often works out) had some Turkish slaves and told them he wanted to build a "weird" place. One brief text tells me that the architect of the garden was Pirro Ligorio, an archaeologist and painter, born in Naples in 1513. The Duke (Vicino Orsini) had it constructed out of his love for Princess Giulia Farnese. There is much more of the story that I wish we knew.

Giant, intolerant heads were the thing. I can't remember which Republican Congressman this one depicts. You could have drinks in this creepy pavilion, for instance. "I'll have a Nigger Negroni, thanks, with a liberal chaser." How odd, and fairly repellent it all is.

Back then, it was covered in ivy and weeds and trees. Now, it's probably as stripped bare as Disney World. Five bucks to park, and it's crawling with pizza-eaters from Stuttgart and Peoria. Maybe it's not even worth a try?

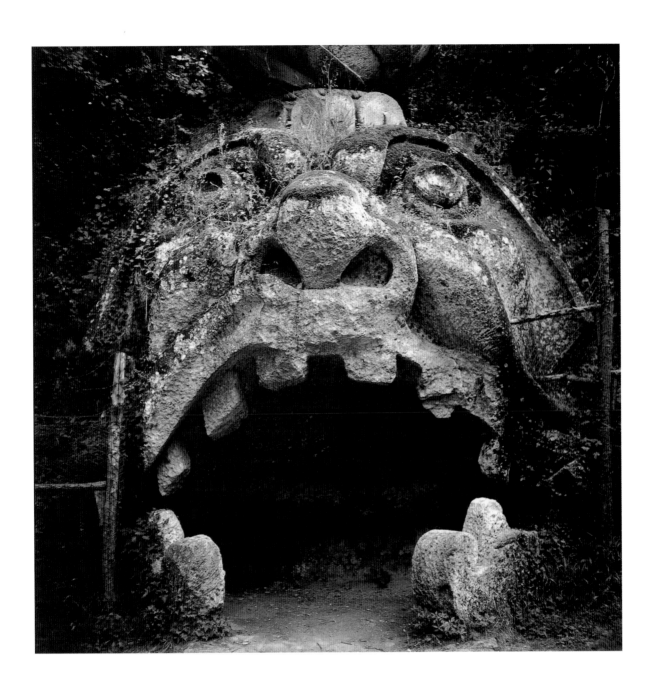

SAINT KEITH OF CAYUGA STREET,
ROCHESTER, NEW YORK

KEITH SMITH (1938 —), this photographer, artist, and bookmaker is one of the best people in these United States. A thousand or two Murkins know this; the rest have absolutely no need to know. Think of something more important, like the next trip to Wal-Mart to buy 100 rolls of toilet paper and 500 Ibuprofen caplets.

You know him or you don't know him. That's cool. The millions of goons mourning Jerry Garcia *ce soir*, should keep doing what they are doing.

If Great Gay Artist means anything at all, it means something here. With or without the NEA or the help of even one pol or prole, Keith will be working 18 hours a day. Like Robert Hughes suggests: he's a fucking weed! Just permit him a cement sidewalk with one crack in it. There is no way your inattention will stop him.

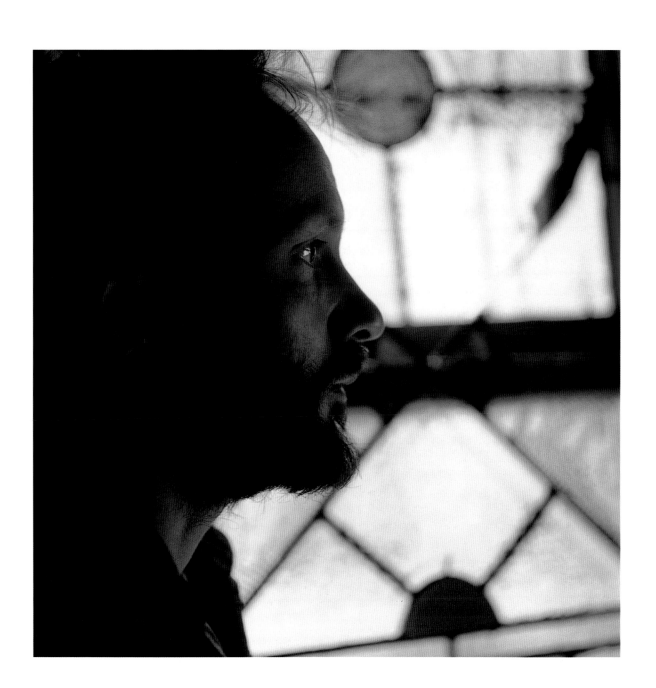

LOU HARRISON
(1917—)

I FIRST SAW LOU HARRISON at Town Hall in Manhattan one night in February, 1949. It was for the first performance of Charles Ives's *First Piano Sonata*, performed by Billy Masselos. Lou had edited and re-created the score from an old manuscript and some rough sketches. It was one of the greatest instances of piano playing I have ever heard. I can still feel it after 53 years. I remember Wallingford Riegger in the audience that night, obviously very moved. And so was Edgard Varèse. I imagine that Virgil Thomson, Aaron Copland, Henry Cowell, and Leonard Bernstein were there, but I didn't see them.

I next saw Lou at Black Mountain College the summer of 1951 and got to be a good friend. For some reason I remember when I was driving into Asheville to the A B C store, he would ask me to get him a bottle of Rock and Rye. This is a cordial made of rye whiskey flavored with rock candy syrup and fruits—revoltingly sweet. Lou's the only person I have ever met who liked the stuff. He may have been the last buyer? It's not in the A B C store now.

Our paths have crossed often over the years. From the old days in California when he and John Cage studied with Henry Cowell and Arnold Schoenberg, Lou's reputation as a master composer, an "original" in the tradition of Charles Ives and Carl Ruggles, has become known worldwide. By his 80th birthday, his musical catalog was over 300 pieces. He is also known for his painting and superb calligraphy; or his poems (Jargon published a book of them, *Joys & Perplexities*); his building of gamelan orchestras and medieval instruments; his knowledge of Asian music; his interest in just intonation and tuning; his critical writing. He is composing a world in this, his 85th year. The book to read is *Lou Harrison*; by Leta E. Miller and Frederic Lieberman (Oxford University Press, 1998).

When asked "Do you see any continuum in the progress of Western music and, if so, where would you place your own work?" he retorted (with characteristic good humor), "As for the first sentence, I haven't the faintest idea, and in answer to the second, I can only say, 'Lou Harrison is an old man who's had a lot of fun.'"

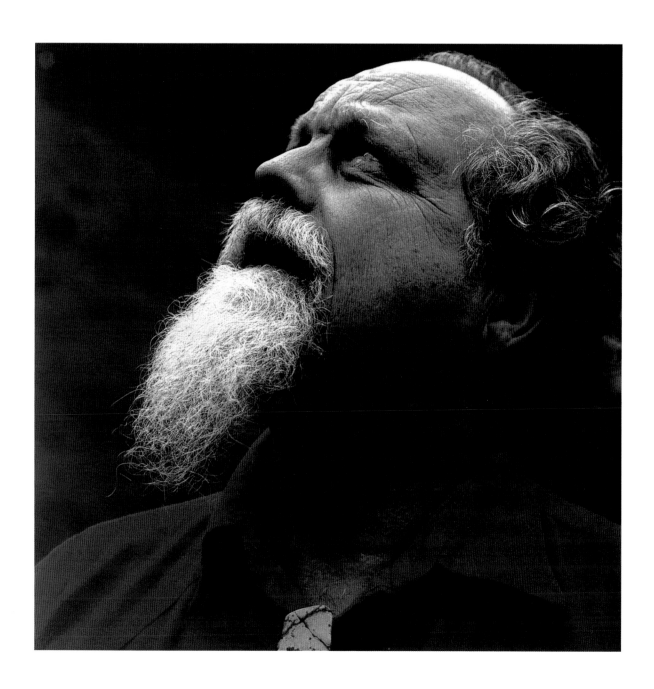

PAUL METCALF
(1917–1999)

T HE K ING OF THE C RANKS, doing a Grant Wood number (ouch!), at his rural retreat, "Wild Thymes," in the Berkshire Hills above Chester, Massachusetts.

Mr. Melville's great-grandson has been cranking out severe texts in majestic fashion since Jargon first published him in 1956. William Gass and Guy Davenport have assured us for a long, long time that he is one of our best, but that doesn't seem to have done much to convince the unconvincible. We just keep publishing the next book. *Araminta and the Coyotes* was the last one.

Since the Old Scrivener has checked the pulse of the Boston Red Sox for ruinous decades to little avail, I am placing a call to Space-Man and Dr. Strange-Glove and Long-Tater, Oil Can, and the one and only Don "Bad Hands" Buddin to see what they make of all of this. Maybe they are all avid fans of *Genoa* and *Patagoni* and *Both*? You can't hit what you don't see.

Coda: Paul died a few weeks ago, all of a sudden, just like that. He and his wife Nancy had bought a bag of apples at a farmers' market just down the road from "Arrowhead," his great-grandfather's house near Pittsfield. Let the Red Sox do their worst!

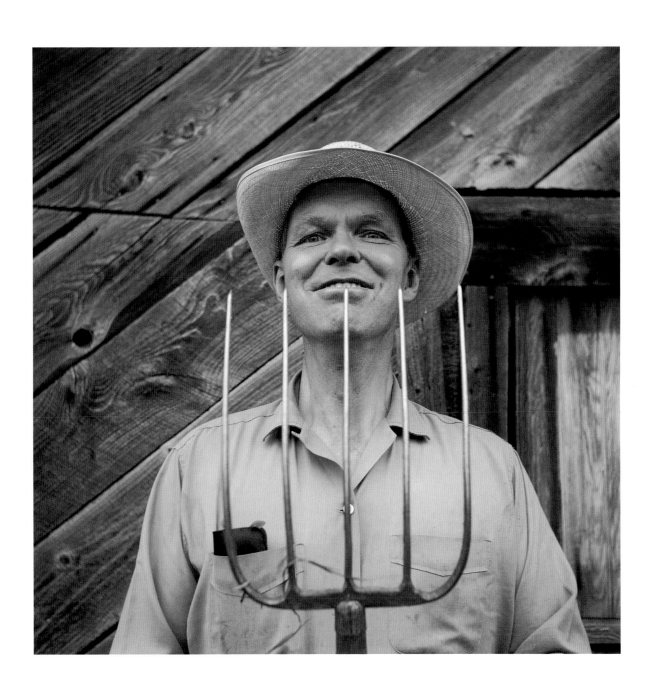

EDWARD ESTLIN CUMMINGS
(1894–1962)

Isn't it great that the grand poet of lower case democratic liberality has a classic grave in Forest Hills Cemetery in Jamaica Plain, South Boston, with nothing on it but New England capital grandeur?

I hesitate to ask if any of you nineteenninetyninemurkins read even one word of the master. The answer might bemuse me, and cause me to draw the curtains, turn on the Atlanta Braves, and sip steadily from the jug.

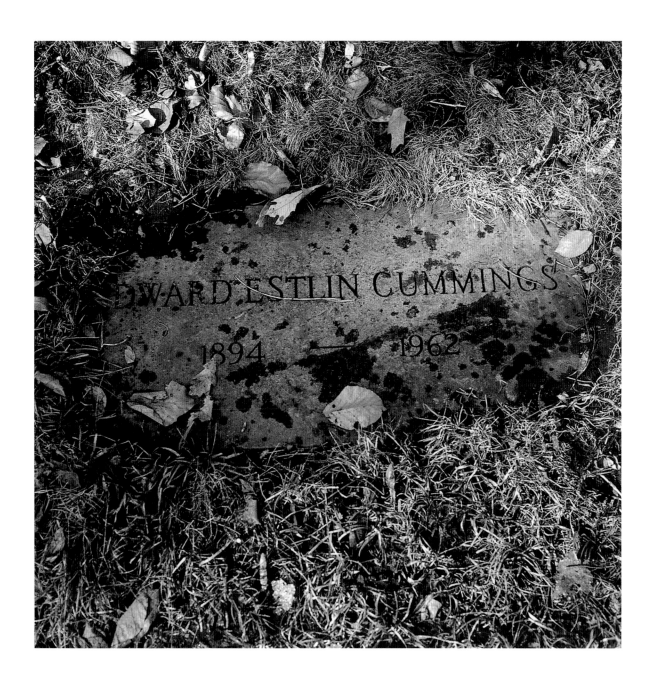

CHARLES JOHN OLSON, JR.
(1910-1970)

THE BIG O (about 6'8", weighing in at 275 lbs, minimum) always said this photo of him in front of lobster pots in Gloucester, Massachusetts, made him "look like a Nazi physician."

One of my gents. Back in the 1950s I studied with him at Black Mountain College and published the three earliest segments of *The Maximus Poems*. For sheer symphonic reach there has been little in our poetry to touch it. Early Wynn (one of the great names for a major league pitcher) would brush you back with "chin music." The Big O would stick his music in your ear. You have to go to New England composers like Ives and Ruggles to come anywhere close. Charles, with his big eyes and glorious blarney, would say that he'd never heard of these guys. A bit of a laugh!

I miss him a lot. The bigness, the genius, the fun. He said Elvis was the Young Orpheus. He'd never heard much Elvis either. (He once confided that the Boulez *Second Piano Sonata* was the only thing since Bach. But, if he knew one single piece by Bach, he never told me.) No matter. Poets talk more trash than politicians. VOTE FOR O! If he were here now, I'd suggest Roseanne for President, Robin Williams for Vice President, and Charles Olson for Secretary of State. Working people would be well served, the arts would be well served, and it would drive the fundamentalist assholes around the bend and over the cliff.

His grave in the cemetery filled with Portuguese fishermen in Gloucester, Massachusetts, is a strange and moving one. The fishermen have grandiloquent Roman Catholic memorials like big wedding cakes. Olson has this thin little black-slate Puritan monument in 17th-century style, complete with a *memento mori* death's head. Sadly, the carving is uncaring and all too feeble. Carving is like most things now. There's little good carving since Richardson and Sullivan.

He said: "There are four legs to stand on, The first, be romantic. The second, be passionate. The third, be imaginative. And the fourth, never be rushed."

AMO, O!

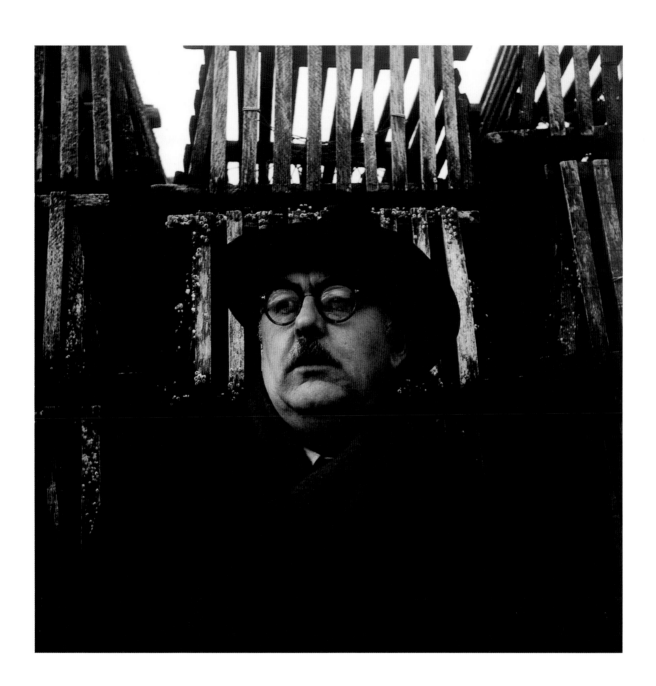

R. BUCKMINSTER FULLER
(1895-1983)

BUCKY, OUTSIDE HIS DOME HOUSE, in Carbondale, Illinois, circa 1960. He described himself as an "explorer in comprehensive, anticipatory design science." This Heap-Big Little General of the Generalists seemed to know it all.

Back in 1962 we published his *Untitled Epic Poem on the History of Industrialization*. Poets hated it (including Charles Olson). Bucky just smiled and said: "If you don't think it's poetry, then call it ventilated prose." More cogently he said: "The poet is the man who puts things together."

Everybody who knew Bucky had a wealth of anecdotes. I like to remember the evening in 1963 when Ronald Johnson and I invited R. Buckminster Fuller and William Seward Burroughs to dinner at our flat in Hampstead, overlooking the Thames Valley. The first triumph was that neither knew who the other was! The conversation turned to viruses. Said Bucky: "I say, old man, have I told you that we are now able to chart the structure of many viruses?" And the other old Harvard man said: "Viruses, hey man, do you know Dr. Enders? I happen to have secret information that streams of alien viruses are filtering into the Solar System a this very moment from the Galaxy Boybutt."

The only moment when our two guests reached any common accord or understanding was in reacting to Mr. Johnson's lemon pie. Burroughs exclaimed: "Man, that is the craziest lemon pie, like, I mean the craziest." Fortunately two had been made, as WSB ate a whole one.

When I went years later to Bucky's modest grave in Mount Auburn Cemetery, Cambridge, Massachusetts, I looked at the inscription. It says: "CALL ME TRIMTAB." Geodesic Melville! What a thrilling bear-cub of a man in Murray Space Shoes he was.

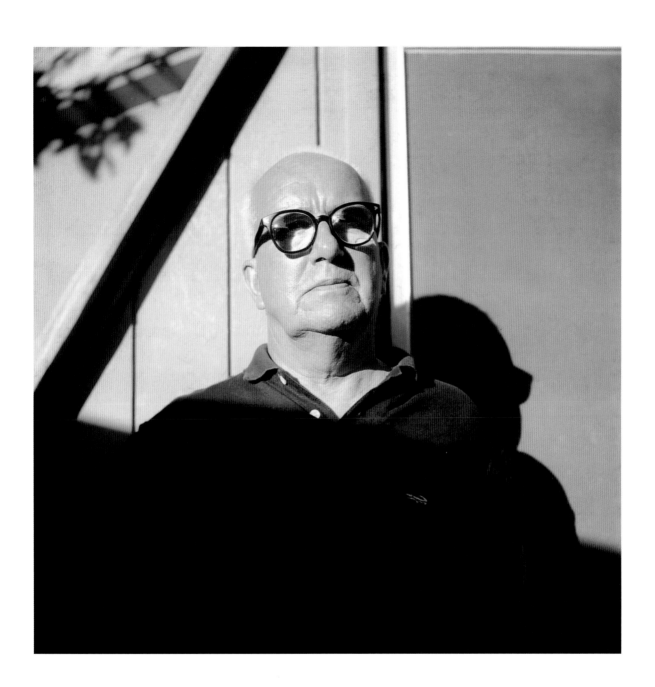

GUY DAVENPORT
(1927—)

The Sage of Sayre Avenue, Lexington, Kentucky, at his typewriter. His letters, to this day, are typed neatly, on various letterheads with designs, collages, and drawings sometimes thrown in. They are directed to one person from one person. Literacy may be on its last legs, but G. Davenport is still at work, a saner lapidary stylist than anyone I know. He wrote recently: "Richard Sennett in the *TLS*'s survey of Favorite Books of the Millennium plumbs for Montaigne's *Essays*, the best of which, he says, is 'The Ascent of Mont Ventoux' [which is by Francesco Petrarca]." How fortunate he is to wake in the morning and not see a stack of ugly, mostly stupid e-mail printouts. Perhaps the WorldWideWeb is really a younger sister of the gorgon, Medusa? Look more than once and you might be turned to stone — or something considerably less pleasant.

Guy Mattison Davenport, born in Anderson, South Carolina, is a stickler for facts. I believe his father worked for the Southern Railway, and that may have something to do with it. You want the crossings safe and the trains to run on time. Same with words.

What can I tell you about Cousin Guy? Well, for one thing, as a Man of American Letters in these squalid times, he is our best. *The Geography of the Imagination* is a book of essays like few others. You'll learn things about Hobbits, Whitman, Ezra Pound, Grant Wood, Tchelitchew, Ronald Johnson, and a host of others that you never ever even thought about. It sizzles. It's damp between the toes. Hugh Kenner says: "He is the best explicator of the arts alive, because he assumes that the artists — painters, poets, describers of natural wonders — have the sort of mind he has: quick, unpredictable, alert for gaps to traverse toward the unexpected terminus."

His fiction is not admired by Mrs. Jesse Helms.

The Spanish translator of his story about the discovery of the Lascaux Cave couldn't figure out the names of any of the plants and trees mentioned. Since G. Davenport didn't know the Dordogne region all that well, he simply used the names of things he knew from growing up in upstate South Carolina. Such legerdemain is refreshing now that we are surrounded by militias, mind parasites, and defenders of the "holy truth."

It is both wonderful and sobering to sit for an afternoon in the Professor's parlor. He once asked me if I could prove that Vincent van Gogh actually existed and wasn't just a creation of his brother Theo. He said, "There seems to be no known photograph of van Gogh. I find that odd." Every word, every thought, every aside is checked in encyclopedias and dictionaries, biographies, and histories. I told him I definitely wanted college credit next time I came!

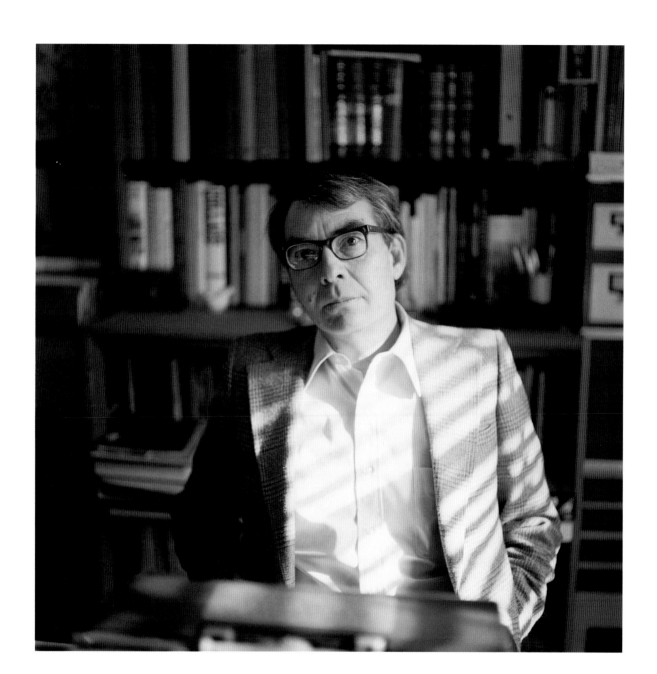

HOWARD PHILLIPS LOVECRAFT
(1890–1937)

HPL IS BURIED in Swan Point Cemetery, Providence, Rhode Island, in a fine situation above the Seekonk River. Thirty years ago, his name was merely added to a family grave marker. Minor literary and B-movie fame has produced this new stone. I don't really know what it means.

I read a story of his in *Great Tales of Terror and the Supernatural* when I was 15 and immediately began buying his books. Ben Abramson, the famous old bookseller of the Argus Bookshop in New York City, sold me the Arkham House rarities, *The Outsider* and *Beyond the Wall of Sleep.* Just the right lubricious adolescent tang: "Bigger'n a barn . . . all made o' squirmin' ropes . . . hull thing sort o' shaped like a hen's egg bigger'n anything, with dozens o' legs like hogsheads that haff shut up when they step . . . nothin' solid about it — all like jelly, an' made o' sep'rit wrigglin' ropes pushed clost together . . . great bulgin' eyes all over it . . . pipes, an' all a-tossin' an' openin' an' shuttin' . . . all grey, with kinder blue or purple rings . . . an' Gawd in Heaven — that haff face on top! . . ."

"*Eh-ya-ya-ya-yahaah — e'yayayayaaa . . . ngh'aaaaa . . . ngh'aaa . . .* h'yuh . . . h'yuh . . . HELP! HELP! . . .ff—ff—ff—FATHER! FATHER! YOG-SOTHOTH! . . ."

In 1999 this sounds more like a bunch of Republican presidential contenders courting Pat Robertson's crackpots than some eldritch Old One evoked by Wizard Whateley in the Miskatonic Hills of western Massachusetts. But, hang in there, it's still worth it to froth in primal slime at the center of nuclear chaos with those congeries of iridescent globes, etc. How can it not be?

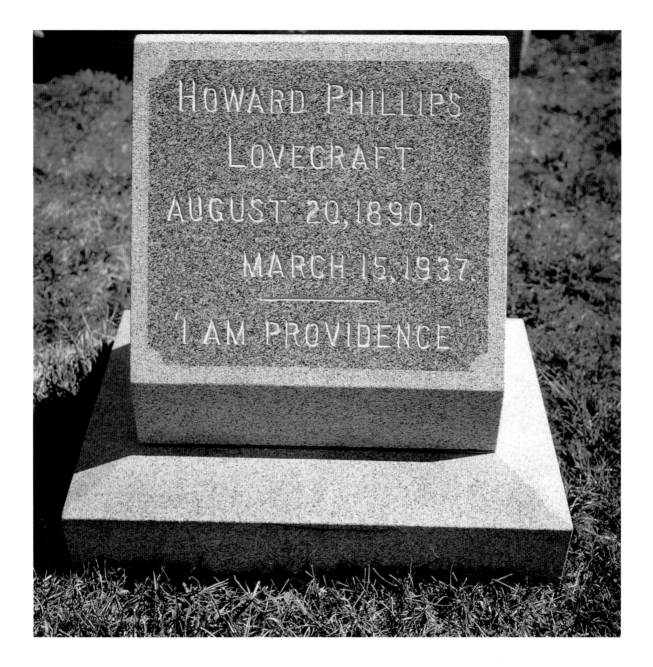

DOM PIERRE SYLVESTER HOUEDARD, OSB
(1924–1992)

HERE IS SYLVESTER outside the south door of the Church of SS Mary and David, Kilpeck, Herefordshire, on the Welsh Border. It is the most amazing Norman church in Britain, circa 1145, with influences from Santiago de Compostela in Galicia, erotic Celtic survivals, and touches of Disney-like whimsy.

Dom Sylvester was what one might call "vastly remarkable." Benedictine monk; foremost scholar of the history of the visual poem; and excellent maker of verbal icons on his typewriter. Since I had no personal contact with either Ronald Firbank or Stephen Tennant, dsh (as he signed himself) more than filled this wacky void for me. One day his impeccably typed epistle would contain a list of people one simply had to seek out and know. The list always included improbable friends with names like David Borgia Duck and Dacre Punt. They were real, in fact, just as my own travels have introduced me to personages named Cocky St. Jock, Anna Banana, Rilke Microwave, Antler, Sister Boom-Boom, Ford Betty Ford, and Too Tall Jones. Another mailing would include a lengthy treatise on *Oneiric Figuration in Late-Hittite Hieroglyphics*.

I met him first in the bus station in Newbury, Berkshire, back in the spring of 1963. I remember the awe that he produced in the good C of E burghers of the town: black habit, white silk scarf dragging the ground, black beret, black sunglasses. All this, plus a manner of speech that suggested Kenneth Williams in full cry.

There was a remarkable day a year or two later on when I arrived at Prinknash Abbey to take him on an outing. "Local pub's closed today," said dsh, "but they say the Bear at Rodborough serves a decent lunch." The Bear's menu offered all sorts of over-stuffed, stock-brokerish excesses. I asked him if he perhaps would like to have the lobster salad? "Actually," he said, "the whole boiled lobster is just what I'd like. And, I see, they have a very good *grand cru* Chablis, let's have that." So, even back in the 1960s, lunch in the Cotswolds could manage to cost about 25 pounds each. No matter. The fare at his abbey must have been dreary indeed.

To repay my hospitality, he then said: "Now, you must meet some people near here. The nice thing is that their names all begin with V." Vintage Sylvester! And so we drove off to see (1) the young Simon Verity, stonecarver, in his studio at Oliver Hill's house, "Daneway" . . . (2) Rosemary and David Verey, newly embarked upon their garden at Barnsley House, near Cirencester . . . and (3) David Vickery, living in a parsonage north of Chippenham once occupied by the Rev. Francis Kilvert. Only dsh could have managed all that. All of his friends miss this debonair (but devoted) man. I wonder if he ever found the reincarnation of Arthur Rimbaud, glowering in the corner of a rough English pub? I said to him once: "Silver-Star, ask that dishy, butch boy over there if his name is Arty Rainbow. If it is, you win. You win big!"

ELIJAH PIERCE
(1892-1984)

Mr. Pierce's poise and dignity are very apparent. Here he is in front of his barbershop on Long Street in Columbus, Ohio, about 1980. He barbered all his life and was one of the greatest African-American woodcarvers. The core of his work was a series of religious reliefs: a remarkable Crucifixion, Adam and Eve, Noah's Ark, Jonah and the Whale, the Story of Job, Samson. Also, many secular pieces: Louis vs. Braddock, Popeye, Mr. and Mrs. Hank Aaron, Abraham Lincoln, Martin Luther King, Jr. and the Kennedy Brothers, Card Players, The Grim Reaper, Three Ways to Send a Message: Telephone, Telegram, Tell-A-Woman, Nixon Being Driven From the White House. He was also a minister and a Mason.

"Most of the carvings are from a vision I see. I see a picture in the wood or hear a sermon in the wood . . . I usually pray over a piece of wood before I ever put a knife in it. I pray to Him for inspiration."

"God speaks to me. I know his voice. 'Elijah, your life is a book, and every day you write a page, and when you are done you won't be able to deny it because you wrote it yourself.'"

"I've had ninety-two years of backaches and ninety-two years of headaches, I'm tired of all this work. But I'll stay as long as I'm needed. We never know what He will want of us."

There is an excellent catalogue that accompanied the exhibition *Elijah Pierce, Woodcarver*, organized by the Columbus Museum of Art. This paperback is distributed by the University of Washington Press. The Columbus Museum of Art has over 100 works by Elijah Pierce. My next trip to Ohio will certainly include it.

THORNTON DIAL, SENIOR
(1928—)

"BUCK" DIAL MAKES ME THINK of something Clyfford Still once said to me over lunch in Baltimore: "Listen, I've been painting for 37 years and when I put paint on a canvas, I'm not kidding."

For a black man from Bessemer, Alabama, who's worked hard all his life as a house painter, a carpenter, and an iron worker for 30 years at the Pullman Company making box cars, to be also an artist with the passion and intensity of a Still or a David Smith, and the inventiveness of a sculptor like James Surls, may make some uncomfortable and incredulous. It's true, so let it make them uncomfortable and incredulous. "Buck Dial, you go way from here, you stop messin' with that art. That art is for the white folks!" Ah, the *cri de coeur* in the breast of all of us recovering racists . . .

Dial knows very well what he is here to do: "God made man to understand life, if you got college degrees or if you just got common sense, mother's wit. Mother's wit is where ideas come from. Since I got the opportunity to speak like I can, I give the best I know. I can't read and spell but I got a mind and I can speak with any man. I might say something in my art that somebody ain't never heard before. Life is so hard for people when they don't understand."

"I'm proud something good happened before I died."

LeRoi Jones (Imiri Baraka) writes persuasively in *Thornton Dial: Image of the Tiger* (Abrams, NYC, 1993): "Dial raps about *here*. About the Black Belt. About Niggers and White Folks and the funky, funky world."

My old friend LeRoi is as unrelenting as ever, I am glad to report, and he does make the eyes go round and puts you on your toes: "Wagner was Hitler's Bebop, The Rolling Stones have spoken directly of their vehicular mode of racism and gender oppression. What was Rodin's *The Thinker* thinking about? Well, check the year it was created, and what was Europe doing? Well, colonizing Africa, Asia, Latin America." Well, an old ironist like me often thinks *The Thinker* was wondering whether or not he'd told the washerwoman to put no starch in his collars. Still, LeRoi may have it right after all.

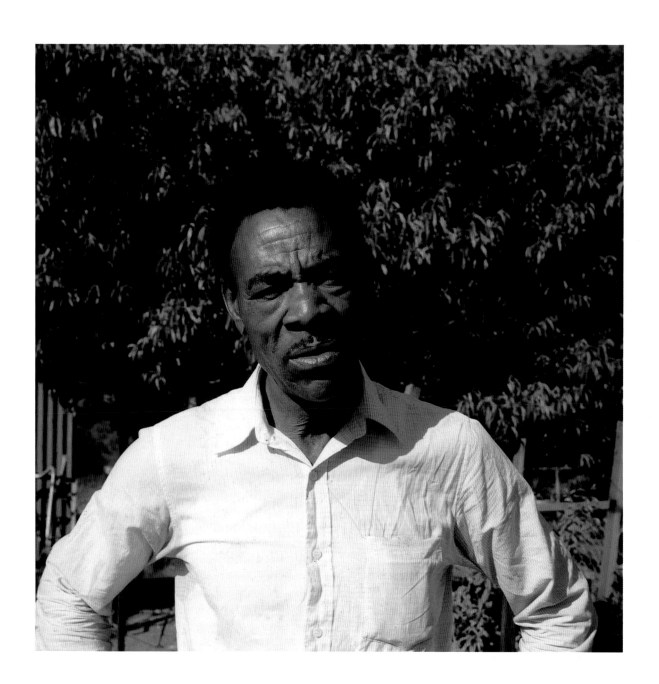

THE IDEAL DREAM PALACE OF THE POSTMAN CHEVAL

THIS HAS BEEN A PLACE of surrealist pilgrimage for quite some time now — the Imagination's answer to Santiago de Compostela.

How to find it? (There is a story that Miss Stein and Miss Toklas and the ghastly Cecil Beaton hired a taxi in Paris to get them there. Well, it's only about 250 miles.) Hauterives (Drôme) is a little town east of the Rhone, about an hour south of Vienne. You can buy very good local walnut oil. The two times we have visited, we have dined at Fernand Point's famous Restaurant de la Pyramide in Vienne first, thus making two of the richer days of one's life.

Joseph Ferdinand Cheval (1836–1924) began to build the Dream Palace in 1879. He said: "I built, in a dream, a palace, a chateau of grottoes . . . so pretty, so picturesque, that ten years after it was still engraved in my memory so that I was never able to escape it . . . Then after 15 years, when I had begun to forget my dream a little, I thought less of the world: it was my foot that recalled me . . . My foot had caught an obstacle that made me fall; I had wanted to know what it was. It was a stone of such bizarre form that I put it in my pocket in order to admire it at my convenience."

From that little episode, he added to the first stone (Hauterives is in an alluvial valley filled with water-smoothed stones) and spent the next 33 years alone at the task. He wrote:

I have placed this
monument

under the care
of three

giants.

My wheelbarrow
is in
a special

niche.

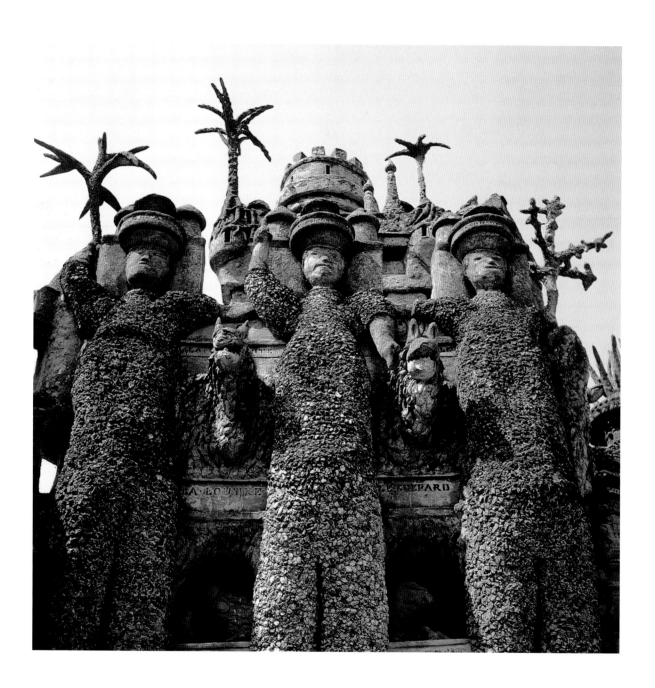

JACK SPICER
(1925–1965)

Dear Jack,

Over 45 years since I took this photo of you in Mendocino County, somewhere between Fort Bragg and Clear Lake. I wonder if there are still any trees in that part of California? I wonder if you were as hung over as I was, after playing pinball and drinking most of Saturday night in that bar full of Finnish woodchoppers? (The answer is yes.)

"Poetry is for poets," that's something you said. And goatry is for goats . . . Certainly, *Der Spicerkreis* endures in many (so, maybe it's a *few* — who's counting?) hearts. The older bards (Robin Blaser, Gerrit Lansing, James Broughton, the late Ronald Johnson) never leave you out of their thoughts for long. And younger ones (Tom Meyer, Jeffery Beam, Jim Cory, C. A. Conrad, Brian Lucas) still get moist in the crotch from the love-snares in your words. So, poets know you, and in no way have you been turned into academic grist in desolate brain factories.

America in the 1990s is not your kind of territory. Lots of fireless poems. Lots of gangsta rap. Lots of slams, lots of literary scams . . . Lots of De-Construction. Not a lot of sexy boys around, "cute and dumb and full of cum." The scrofulous redneck media issues books about the President of the United States in which the incumbent, a former Governor of the finger-lickin' State of Arkansas by the name of Bill Clinton, is quoted as saying: "My wife Hillary eats a lot more pussy than I do." Can you imagine Warren Harding saying that? Or anyone being prepared to listen? Ezra Pound taught us poets to be genteel!

More importantly, major-league baseball is now some sort of multi-galactic money game run by bestial aliens. Still, you are missing one pitcher worthy of your scrutiny: Greg Maddux, right-hander for the Atlanta Braves. At the moment (20 August 1998), he is 13–2, in a five-man rotation. In one recent stretch he didn't walk a batter in 180 appearances at the plate. A 1.74 E.R.A. About 10 K's a game. Easy motion. Six deliveries: fastball, cutter, sinker, slider, curveball, and a demonic circle change, where the bottom simply falls out. He throws strikes two-thirds of the time — they still can't hit him. The team calls him "Mad Dog," but he actually performs like a brain surgeon or a veteran shoe salesman — few interviews, no jive, all quietness and vast concentration. Check it out!

If you can get a flight from Elysium to Hartsfield International Airport, I'll pick you up at the gate any night. Two tickets on the first-base side at Turner Field, front row behind the backstop, next to the dugout. You'll like the batboy.

Love,

THE WATTS MORTUARY CHAPEL, COMPTON, SURREY

MARY FRAZER-TYTLER WATTS, the young second wife of George Frederick Watts, Victorian painter of the famous "Hope," and Honorary President of the Anti-Tight Lacing Society (Gertie Tipple, Secretary), in her designs for the Watts Memorial Chapel at Compton (about 3 miles west of Guildford in Surrey) created one of the unique fantasies in all of architecture. A bit of Byzantine, a bit of Celtic, a bit of Norman, a bit of Tuscan, lots of Art Nouveau, and a touch of what you might call Obsessive Theosophical. The round interior, with four transepts, is decorated within an inch of its life.

Watts, himself, needs revision on the basis of such paintings as *The Sower of Systems*. That and many other paintings by Watts may be seen at the Gallery adjacent to the Chapel. Watts is a minor-league Gustave Moreau. After all, to quote the authoritative words of Violet A. Wlock, B.A., Deputy Curator of the Castle Museum, York, 1938–47, in her "A Chat on the Valentine":

"Crinolines are creeping their way to fashion, there is even a whisper of tight lacing . . ."

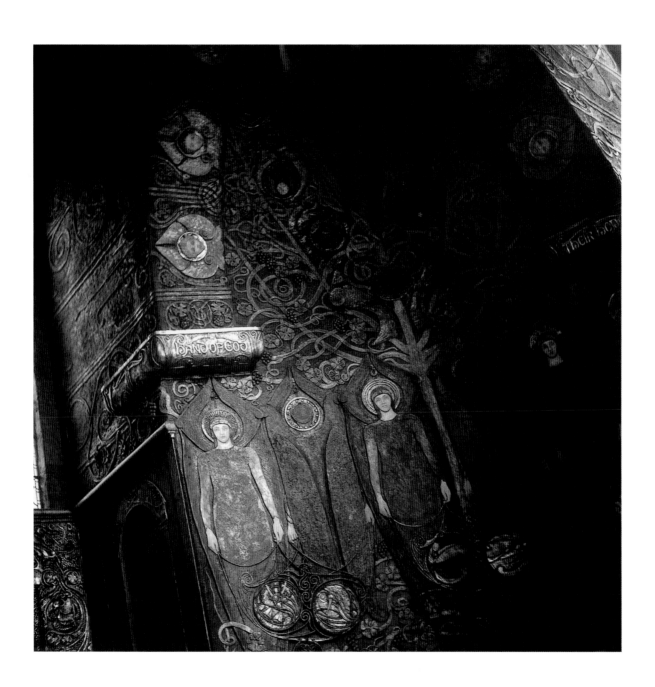

HOWARD FINSTER, THE MAN OF VISIONS
(1916–2001)

THE FIRST TIME I EVER HEARD of the Rev. Howard Finster was in the pages of *Missing Pieces: Georgia Folk Art 1770-1976*, that useful catalogue published in honor of the American Bicentennial by the Georgia Council for the Arts and Humanities. I made a note to visit Pennville and see the Paradise Garden, which I persisted in calling the New Improved Garden of Eden, just to be ornery. It is not my custom to have much truck with country preachers, but Howard isn't your average snake-eyed Bible-thumper, no way.

Before getting there, I discussed it all with that bodacious sight-and-a-half, Eddie Owens Martin, St. EOM, of the Land of Pasaquan. Howard called him the "Big Injun," though EOM swore there wasn't a drop of Creek or Seminole in him. The Big Injun confided: "I mean, I just love to tempt men of the cloth." He'd get on the phone and say: "Reverend Finster, yessir, good buddy, thishere is Eddie Martin. I sure would like to get into your pants, yessir, Reverend!" (This is one of those telephone conversations you doubt ever got made.) No matter. The Rev. Finster, a righteous Baptist of northwest Georgia persuasion, talks about "queery boys" just as one might expect. No matter. I have never heard him speak unkindly of his great contemporary, Eddie Owens Martin, who was gayer than a square grape.

Tom Patterson and I got to Pennville in March, 1980. Let me tell you how to go. The way I describe avoids having to drive through Rome, Georgia. Take I-75 northwest from Atlanta. Take Exit 128. Go west on Highway 140, through Pinson to Armuchee. Turn right on Highway 27 towards Summerville. Pennville is two or three miles north of Summerville on Highway 27. Paradise Garden is on the east side of the village. Make a right turn and you'll find it. At a guess: one hour thirty/forty minutes from Atlanta.

The first thing I bought from Howard is a little painting of George Washington on a wood plaque. It's dated 1976, the year the Voice told Howard to "paint sacred art." It's numbered 427 and another number (55) indicates it took him 55 minutes to paint. By the summer of 1998 the count is nearly 40,000 pieces of art from the Man of Visions. But the years are slowing him down. These days he mostly paints faces on gourds. The sauna bath at the new house he lives in now is filled with 400 gourds drying.

Howard Finster talks with great eloquence:

"I started going to the dump and collecting old broken dishes and molding brick. I'd go to the dump and find some of the prettiest things you've ever seen. Sometimes twenty-two-carat gold dishes would be broke and thrown in there. Most of the stuff here in the garden is junk and not worth anything, and if it is worth anything, I damage it to where it ain't worth anything. I save everything but money."

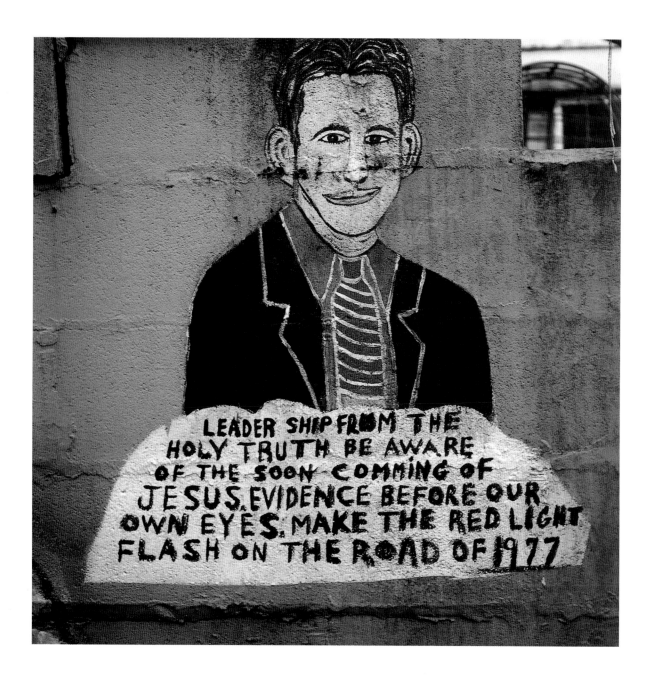

"The longer I live on this planet, the less I can adapt to it . . . here on this world there's nothin' for me except just a little scatterin'ly joy and fellowship, talkin' to my friends. And the rest of it is, 'Howard, your old friend died last night.' They killed 250 of our soldiers. They put glass in the babies' food. They put poison in sick people's medicine. They're talkin' about World War Three. The world is just an awful place, when you get to studyin' about it . . . "

"Nobody's ever come to the planet and stayed here."

Well, Howard, I don't know the name of the planet you came from. But, when it's time for you to go back, I sure hope it offers Classic Coke, red-eye gravy, and okra fried just right by the Duck Woman of Orpliss. You deserve the best!

SIMON CUTTS
(1944—)

I BEAT THE TABLE and bang the drum and bite the bullet, but, so far, convince no one on the Hopelessly Sinking Isle of Angst-le-Tear that S. Cutts is the real escargot, and not just a banana slug. Simon's poetry, like the bit of meat behind the eye of the kipper (the best part) has been ignored sedulously by the Brit/Yank poetasters. They don't like that French muck. We, of course, like it a lot. The Scutts is the Apollinaire of our horrid times. Apollinaire? Say who? Say whut?

Here is the great man outside his bookshop/gallery/press when it functioned in Camberwell, London in the 1980s. Later, it re-surfaced in Narrow Street, Limehouse, and, more recently, moved into Hanbury Street (No. 51), off Brick Lane in Spitalfields, London's Bangladeshi Central, where there's lovely food and no Brits to put up with. Alas, Mr. Cutts and his diminutive and delectable ladywife, Erica Van Horn (book artist), recently decided to flee things English and live in a more agreeable place: the murky mountains of County Tipperary in Eire. So, for now, Coracle is only a press. Simon and Erica travel to the continent on occasion for workshops and exhibitions of their books. Literary London sleeps untroubled.

Simon Cutts is the complete boulevardier/entrepreneur/flâneur. He often manages to beat me to a poem. E.g.:

will the lady
who left
the imitation
snake skin
vanity case
in the cafeteria
please come to
the guards van

You may think that's "easy." Ask Satie or Mompou how easy it is. For that matter, who cares whether it's easy? Can't you stand easy? Dame Nellie Melba once remarked: "There are only two things I like stiff — and one of them's Jell-o."

RAYMOND MOORE
(1920–1987)

WE WOULD OFTEN meet Ray Moore, his wife Mary Cooper, and their young son, David, here at Corn Close, Dentdale, Cumbria; or at The Shepherds Inn in Melmerby, a village on the Penrith/Alston road, at the bottom of Cross Fell and Hartside Pass. Sometimes at The Riverside, in Canonbie, Dumfriesshire. Good ale and better pub food than most.

Ray had his favorite pianists and I had mine. He admired Alfred Brendel in Schubert and, particularly, in Liszt. I would grant that Brendel was incisive and intent, but thought he was dry and lacking in romantic sonority. (That being the case, why is Brendel's Haydn so bright and imaginative? I am too ignorant to know.) I would insist you needed a loony for Liszt, both a demon and an angel, and the man for the job was Mad Vlad Horowitz! Only two days before Ray died I made him stomach the great one roaring through the *Mephisto Waltz* in a way to make the hair stand on end. Only Horowitz would dare joke: "There are three kinds of pianists. Jewish pianists. Homosexual pianists. And Bad pianists!" Horowitz, the Prestidigitator, could work his legerdemain even with the gentle Schubert, as he did in that Lisztian pastiche, *Soirées en Vienne*, included in his late recital in Moscow.

But, if not Horowitz, then, surely, the rock-solid, brilliant Jorge Bolet, or the scintillating Martha Argerich. Nope. Ray wasn't buying. I was forgetting he was a Man From the Kingdom of Northern Grey. I was born under "Carolina Blue," nothing but blue skies, blue skies, all day long, etc. Anyway, this was wonderful time we all spent together under the Cumbrian murk.

To see it takes LIGHT. The Aryan root is *leuk-*, to shine, to be white. Cloud and dark over Britain have put paid to that. William Shenstone strung words like these together: "O'er whose quiescent walls Arachne's unmolested care has drawn pure curtains so subfusk . . ." Some northerners simply fled the spiders south. Oldham, Lancashire's Willie Walton went to Capri. Bowden, Cheshire's John Ireland went to London and the South Downs of East Sussex for cocktail sounds and impressionism. The West Riding of Yorkshire's Bradford Lad, David Hockney, went to sexy, technicolored Hollywood. But, it is one of the major achievements of the best artists on these islands that they have done so much, sat dimly at home, with an infinite range of greys. I now, in fact, will proclaim Raymond Moore as the Honorary President of the *Grey Liberation Society!*

First movement, lento, of a memorial poem, *Three Shades of Grey*, I wrote for Ray in the autumn of 1987 just after his death:

Wie deutlich des Mondes Licht
zur mir spricht

how plainly
moonlight speaks to me

Schubert
spoke through
grey eyes

Schubert
wore a light-grey suit

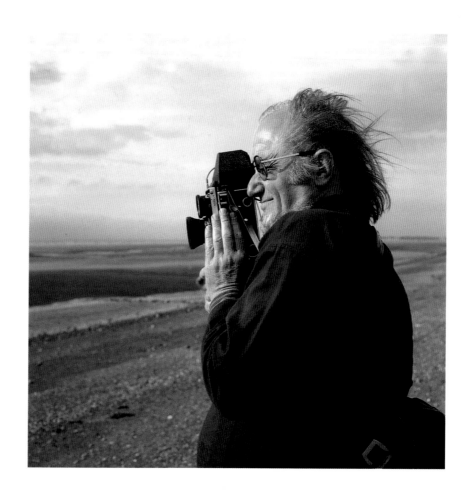

STEVIE SMITH
(1902–1971)

DEAR STEVIE! I knew her from 1963 until 1970, not long before her death. I met her originally through Barbara Jones, that scintillating artist and writer, in whose Hampstead house I had a flat on two occasions in the sixties. Barbara was part of the Olivia Manning / Kay Dick / Neville Braybrooke set who were great fans of Stevie. They drank a lot of gin & tonic and ground their cigarettes into the Turkey carpets with great abandon. It seemed to be the thing to do, with a vengeance, in the London of those days.

I used to go out regularly on the Piccadilly tube to Arno's Green station and walk along to the little house in Avondale Road. The Lion Aunt was very much in evidence on earlier visits. "A house of female habitation," as Stevie wrote. I have seen the charming film, *Stevie*, with Glenda Jackson and Mona Washburn, so many many times that I can no longer quite remember who was the original and who just the actress. (Be sure to have a box of Kleenex at the ready!) Certainly, the best movie about a poet I have ever seen, not to ignore *Waiting for the Moon*, the TV feature about Miss Stein and Miss Toklas, where the actors who play G. Apollinaire and E. Hemingway are absolutely unbelievable, as well as the ladies who play the leads.

The poetry? Slight, perhaps? So what? Not even the great and austere Basil Bunting could bring himself to complain. How touching, and funny, and sad, and honest, she was.

She loved to drink a Black Velvet (half Champers/half Guinness). Stevie, let's drink three!!! And give Death one for the road!

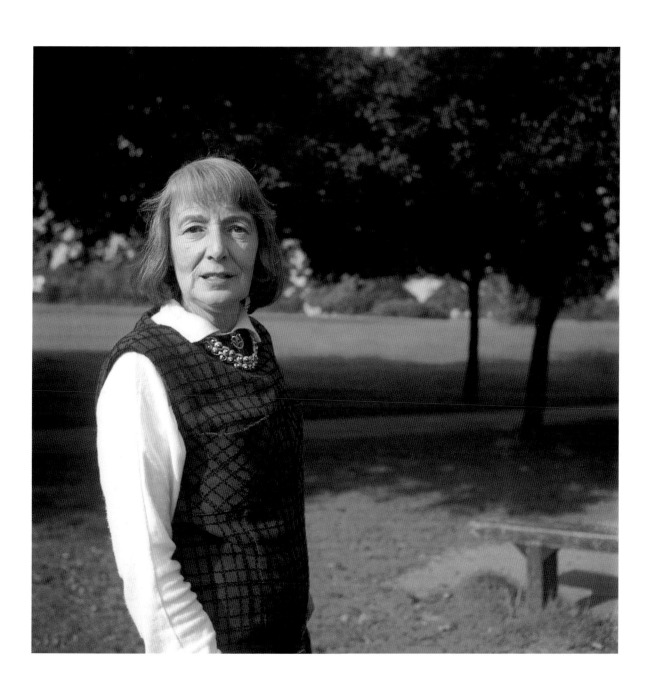

JAMES LAUGHLIN IV — IN HIS STUDY, MEADOW HOUSE, NORFOLK, CONNECTICUT (1914–1997)

FOR ME: YE ROLE MODEL, the only one I ever needed. J was fifteen years older than I, and New Directions started 15 years before Jargon did. The rest is history. Well, if not *history*, then quite lot of work.

Early days in Rapallo (1934–35) when he attended the one and only "Ezuversity," Ez sd: "No, Jaz, it's hopeless. You're never gonna make a writer. No matter how hard you try, you'll never make it. I want you to go back to Amurrica and do something useful." Sez Jaz: "Waaal, Boss, what's useful?" Sez Ez: "Go back and be a publisher."

New Directions has been the best of its kind. Mentors like Doc Williams and Kenneth Rexroth served him well. On the ski slopes of Alta, he listened carefully. And what about the writer?

In the two or three years before his death, there was a spate of JL books — quite amazing. One knew the man was distinguished, but one didn't quite know that the old gentleman had written more good classical poems than Catullus, Martial, Propertius, and Horace put together! The snoring jury is still out, but when hasn't it been? Read Laughlin! Poetry of this order thrills you like cold spring water and high mountain air.

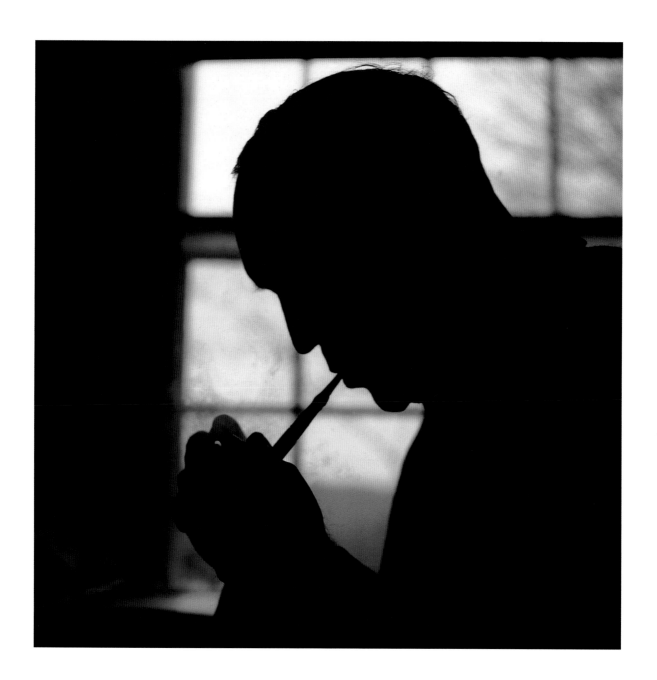

MARTHA NELSON & HER KENTUCKY DOLL BABIES

MARTHA'S DOLLS got involved in yet another vile American Success Story. A white-trash jerk from North Georgia saw her work at the Unicoi State Park Gallery and decided he could "merchandise" it in a big way. He did. And he also claimed to have invented the dolls, established adoption papers, given them names, etc. Total horse dookey!!! These fakes soon became known to the world as the Cabbage Patch Kids and billions were made by various companies and the jerk in Georgia.

Martha suffered a severe emotional blow over the loss of her dolls, but, finally, a decent legal-aid defender stepped in and won her a settlement that at least brought her in a little regular income and a sense of dignity. But, alas, no heart to make more of her delightful little uglified playmates.

As a young girl she made these creatures for her sister and family. They were plain country people without a lot of cash for "toys." The first bald-headed baby was named "Jelly Bean Hawkins." Martha says: "He could be a boy, she could be a girl, he/she could be anything you needed to play with and have fun."

We commissioned Jeremiah Baby back in 1977. Jeremiah is a severe child. He liked visiting T. S. Eliot's grave in East Coker, Somerset. He finds us a bit "frivolous." He was followed in 1984 by the incomparable Otis "Total" Baby, a rustic child who wants to be a knuckle-ball pitcher in the majors, should he ever grow up. (It is beginning to look doubtful, but his disposition remains full of fatback and charm.) Our third acquisition was the pint-sized "Amazing Greg" Baby. Greg is a bit "yup" at times, but he has an opposable thumb and thinks he's pretty hot. Who can argue?

Thank you, Martha, for re-inventing a wonderful American form. Life has always been better since we have had these three cloth-creatures in our hearts and our houses. People who look upon them askance only get in the door one time!

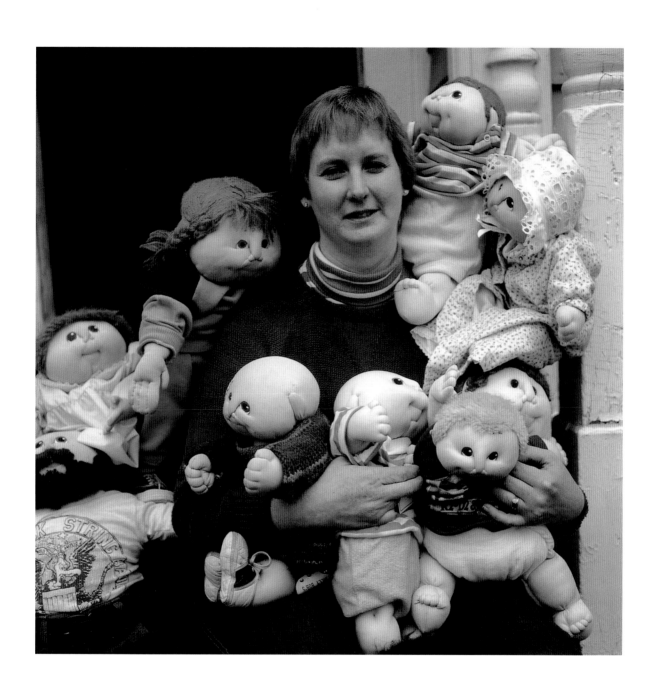

MILES BURKHOLDER CARPENTER
(1889-1985)

IT WAS 1984 before Roger Manley, photographer, and I got ourselves to the little town of Waverly, Virginia, down in the Tidewater, to pay our respects to the ancient, amiable Miles Carpenter. Miles is certainly Old Stock, the Robert Frost look. His companion in the front seat of the car is the equally amiable Miss Lena Wood. "She's been on TV three times already, boys." You will be relieved to know that Miles's old Ford only ventures two blocks to Cootsie's Restaurant, and then back, after a cup of coffee.

This fine old carver was, at 95, batching for himself, taking care of the home place and garden, cooking a little, working a lot. His recipe for a long and vigorous life, as written in his autobiography, *Cutting the Mustard*, is: "Don't drink strong liquor, don't smoke, don't chase around with women . . . And go to bed the same day you get up."

Well, Miles, that makes 95 years feel more like 1095 years. Excuse me out. R.I.P.

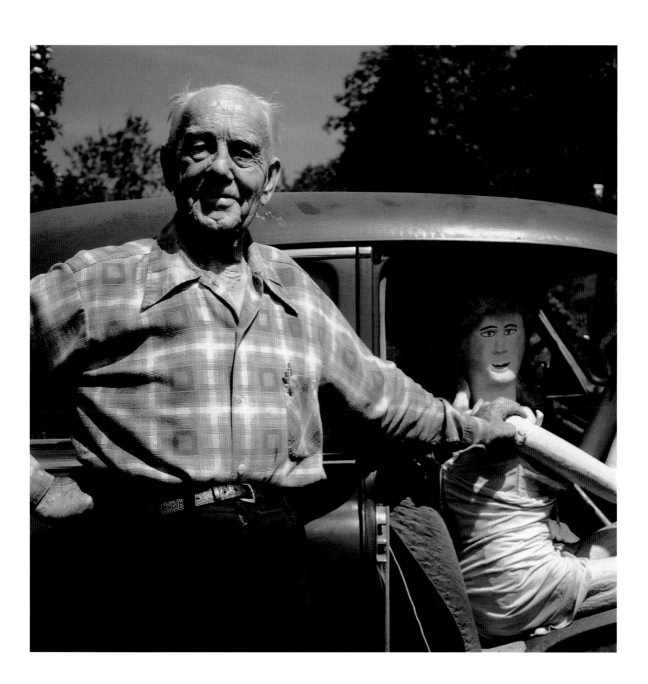

RALPH EUGENE MEATYARD
(1925–1972)

GENE, AMIDST KINKY TULIPS in his backyard in suburban Lexington, Kentucky in the early sixties. Well, the tulips were just tulips and Gene was just Gene, after a manner of speaking. He could make *anything* strange, even Lexington.

I continue to muse upon, be amazed by, be amused by, this singular photographer as much as anyone I have ever known. Not that anyone ever got to know much. Haunted houses don't release press releases.

He was terribly kind, terribly talented. In a way, as remarkable a man with a camera as we have ever had. Henry Holmes Smith told me to go see him in 1960. I did. I am so glad I had the simple gumption to do so. Usually, we never do what our betters suggest.

The first time I met him he told me of heart problems. Later, it was cancer problems of a terribly terminal kind. It seemed impossible. He was infinitely calm and, seemingly, unconcerned.

He was lucky to have a loving family and to be surrounded by intensely devoted Blue Grass friends: Tom Merton, Guy Davenport, Bob May, Jonathan Greene, Wendell Berry, James Baker Hall, Ronald Johnson, Guy Mendes. None of us forgets him for a moment.

Muse-Flash for Ralph Eugene Meatyard:

come on,
Gene

the
Boogers
got

Lummy Jean Licklighter

in an attic
over near Viper!

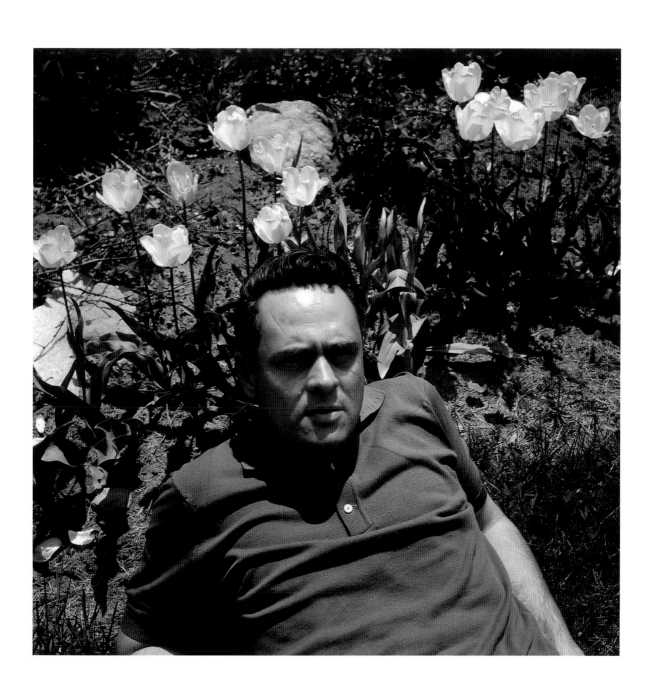

GUY MENDES
(1948—)

A RECENT SHOT of the amiable Deputy-Dawg of American Photography, Mr. G. Marius Mendes III, outside his house, 229 McDowell Road, Lexington, Kentucky, where he resides with his charming wife, Page, and their charming little boys, Wilson and Jess. This Guy is so good! This Guy shoots with such great touch, real Arthur Ashe stuff, that his friends almost want to keep his "career" a secret, a little *lagniappe* just for our own secret pleasure.

He comes out of N'awlins. He remains *boulevardier* and *bricoleur*, re-settled into Central Kentucky, where he misses nothing that needs seeing. Lartigue is his closest peer. In the American Way, the Mendes Clan is pleasantly part-Welsh, part-Grenouille, part-Sephardic. *Keeps the mind active*, as Art Blakey used to say.

Daytimes he is a producer and writer for Kentucky Education Television. I have seen his lovely programs on some of our national treasures like Minnie Black, Edgar Tolson, Ed McClanahan, Lee Smith, and others.

Put on Professor Longhair, Dr. John, Aaron Neville, Sweet Evening Breeze, Sweet Emma, Bradley Harrison Picklesimer, Little Enis, Jerry Lee, James Booker — you'll know about where you are when you look at Tree-Mendous. This is wide-open America, gang. Dig it! "Be there when it happens, write it down."

JAMES THURBER
(1894–1961)

THIS IS IN A CEMETERY near a river to the southwest of Columbus, Ohio. I somehow managed to find it.

Mr. Thurber is not President Millard Fillmore. The rest is up to you.

May God keep you a normal healthy American girl!!!

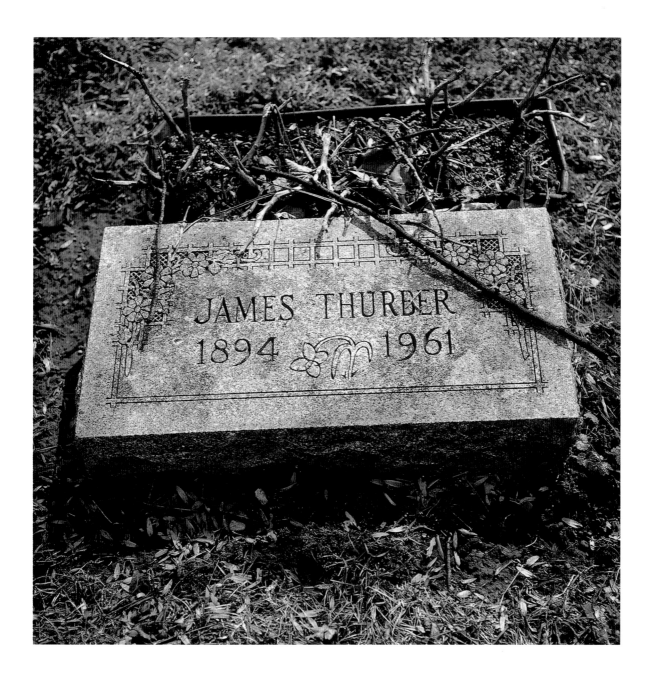

LE PETIT PIQUE-ASSIETTE HOUSE, CHARTRES

RAYMOND ISIDORE was the caretaker of the Saint-Cheron cemetery in Chartres, not far from the great Cathedral. He took home bits and pieces of tile, pottery, porcelain, faience, glass, and various knick-knacks over a long life. He applied them to everything he owned, except, possibly, his dear wife. The "Hodge-Podge House" (you could also call it "The House of the Plate Picker") was in pretty good shape when I saw it in the 1960s. Today? I don't know.

"I was walking in the country when I saw by chance some bits of glass and crockery which I collected for their color and sparkle. I accumulated them in a corner of my garden, then the idea came to me of making a mosaic of my house."

Dans mon

milieu

dans

mon lieu—

and a tiny door

inlaid

in my head

that leads

to the winter

garden.

After me,

nothing dies.

I made it

alone.

My thanks to Ronald Johnson for the translation, which we published in 1969 as Jargon 72, *The Spirit Walks, The Rocks Will Talk,* which also included poems from the Postman Cheval's Ideal Dream Palace, and drawings of Cheval and Isidore by Guy Davenport.

COLOPHON

A PALPABLE ELYSIUM has been set in Kepler, a multiple-master typeface designed by Robert Slimbach for Adobe in 1996. Rooted in the so-called modern types of the late eighteenth century, Kepler was designed to be free of the coldness and formality of its forebears while capitalizing on their refined appearance. Its multiple-master features endow it with the flexibility needed to serve a wide variety of typographic purposes and styles. The display type is Penumbra, a face designed by Lance Hidy in 1995. A concatenation of typographic sources, Penumbra was based on ancient Greek monoline characters, the letters inscribed on the Column of Trajan in Rome, and modern sans serif faces like Futura and Kabel. As with Kepler, Penumbra's multiple-master features make for a chameleonic type, one that is at home in all manner of settings and situations.

This book was designed by David Skolkin.